GREATER ANGLIA: THE FIRST TEN YEARS

ADAM HEAD

First published 2022

Amberley Publishing
The Hill, Stroud
Gloucestershire, GL5 4EP

www.amberley-books.com

Copyright © Adam Head, 2022

The right of Adam Head to be identified as
the Author of this work has been asserted in
accordance with the Copyrights, Designs and
Patents Act 1988.

ISBN 978 1 3981 0552 2 (print)
ISBN 978 1 3981 0553 9 (ebook)

All rights reserved. No part of this book may be
reprinted or reproduced or utilised in any form
or by any electronic, mechanical or other means,
now known or hereafter invented, including
photocopying and recording, or in any information
storage or retrieval system, without the permission
in writing from the Publishers.

British Library Cataloguing in Publication Data.
A catalogue record for this book is available from
the British Library.

Origination by Amberley Publishing.
Printed in the UK.

Introduction

On 5 February 2012, Greater Anglia took over the franchise for the Anglia region. There was no ceremony, just a large snowstorm that blanketed the entire region. The Dutch-owned Abellio took over the franchise after the incumbent operator National Express was stripped of the franchise in 2012.

National Express operated the Anglia franchise for just short of eight years, when it was picked as the new franchise operator in December 2003 with services starting in April 2004. With the combination of Anglia Railways, First Great Eastern (FGE) and West Anglia Great Northern (WAGN) all being merged into one franchise, it needed a new name and National Express took inspiration from what had happened and called the franchise ONE.

Gone went the turquoise of Anglia Railways with their Class 86s, Mk2s and DBSOs, and in came the eye-catching new colours of East Anglia, blue with a rainbow stripe on the ends, which rapidly became a love it or loathe it livery. This livery was applied to most of their stock with only a few trains missing out on the opportunity.

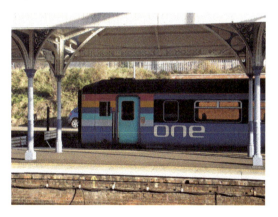

Two of the defining features of the ONE livery was the large unmissable logo and the rainbow stripe found on both cab sides of the unit. No. 156416 sits at Norwich in full ONE livery.

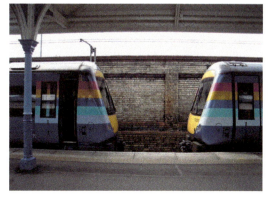

The ONE livery came in two variants, both of which can be seen on Nos 170208 and 170270. The lighter shade of blue seen on No. 170208 would later be the more common of the two and would be used on the rest of the fleet.

In 2008, the confusing name of ONE gave way to National Express East Anglia. This came about when National Express won the East Coast Main Line franchise from GNER in 2007 and named it National Express East Coast. This meant another rebranding exercise across East Anglia. However, there was no new brightly coloured trains; instead they received a white band across the middle of the bodywork with the company name of National Express East Anglia, with only a minority of trains receiving the full National Express livery.

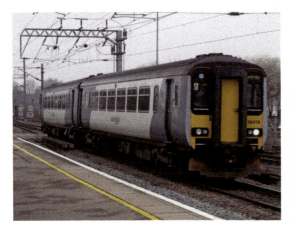

No. 156419 was a unique DMU that wore the full National Express East Anglia livery, arriving into Ely with a service for Cambridge. Displaying the branding of its new operator, it wasn't long after this image was taken that No. 156419 would temporarily leave East Anglia and go to Wolverton for its overhaul.

The Class 170 Turbostars under National Express East Anglia wouldn't receive a new livery. The fleet would instead receive what was called an 'interim' livery, which was comprised of the blue base being kept and the colourful rainbows on the cabs hastily removed, while a white stripe went down the side of the train with the National Express logo on one part of it and the words East Anglia on the other part making up the franchise name.

The only Class 360 Desiro to receive the National Express East Anglia livery was No. 360115, seen at Ipswich operating a semi-fast service to London Liverpool Street. Shortly after this image was taken the National Express branding was to be removed from No. 360115 and it would become blue again.

In 2009, National Express were encountering difficulties on the East Coast Main Line and in November the ECML went back into government hands for the first time since the end of nationalisation. That, however, wasn't the only sting in the tail for National Express as their performance with National Express East Anglia was proving to be good but their three-year extension of the franchise was to be denied and they were to leave East Anglia with a new operator to take over in 2012.

This book will cover where National Express East Anglia leaves off and a new dawn appears in the form of Greater Anglia, who will go on to change rail travel in the area forever.

All the images taken in this book are my own and were taken within the safety rules and regulations of the railways. Remember the railways are a dangerous place and can kill if mistreated.

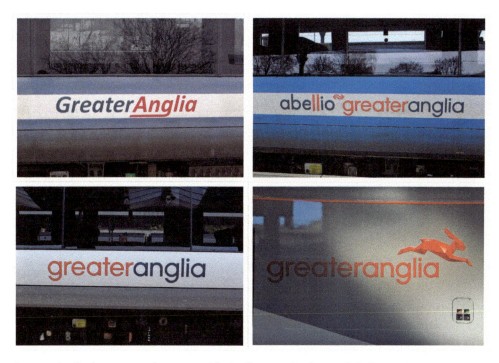

Greater Anglia logos over the years with the first one in the top left from 2012 to 2013, top from 2013 to 2016, bottom left from 2017 to 2020* (*year it left Greater Anglia) and bottom right from 2019 to the present as seen on a new Class 755 FLIRT although only a small number received the hare mascot with the rest just displaying the Greater Anglia logo.

The Early Years: 2012–2016

Greater Anglia inherited all the trains National Express were running at the time, which comprised of the following:

15 x Class 90s complete with Mk3 carriages and Driving Van Trailers.
5 x Class 153 DMUs
9 x Class 156 DMUs
12 x Class 170 DMUs
61 x Class 315 EMUs
51 x Class 317 EMUs
94 x Class 321 EMUs
21 x Class 360 EMUs
30 x Class 379 EMUs

Plus a single Class 150 Sprinter, which was on hire to Greater Anglia.

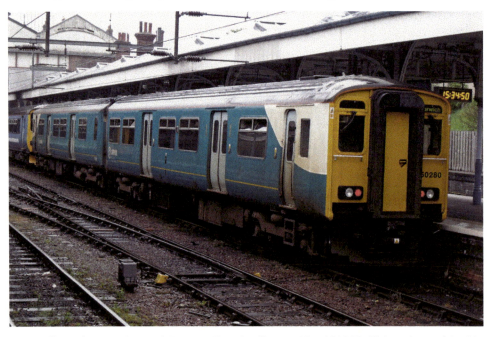

Originally on hire to National Express East Anglia was No. 150280. This unit was hired in after No. 156417 was removed from service after suffering an accident in August 2010. Seen at Norwich still in complete Arriva Trains Wales branding, No. 150280 awaits departure for Great Yarmouth.

During this period, Greater Anglia would see the loss of the Class 315s and a small number of the 317s in 2015 as the lines from London Liverpool Street to Shenfield, Enfield, Cheshunt and Chingford, as well as Romford to Upminster, would be passed over to Transport for London (Shenfield services) and London Overground (Enfield, Cheshunt, Chingford and Romford-Upminster.) The former went onto become part of the Crossrail services in London.

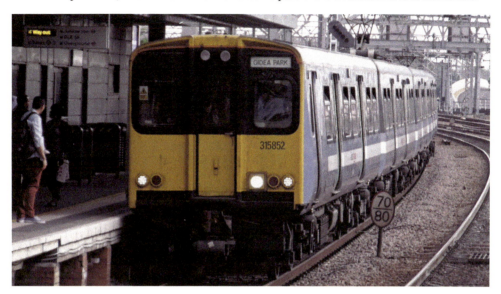

The Class 315s were synonymous with working the all station stopping services between Shenfield and London Liverpool Street, with a regular service operating all day. With the 315s running such an extensive timetable, as soon as one departs it isn't long before another one arrives. No. 315852 arrives into Stratford with a service for Gidea Park.

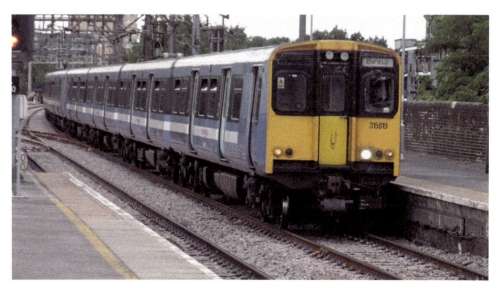

The Class 315s could also been seen working out of London Liverpool Street towards Enfield, Chingford and Cheshunt. No. 315819 arrives into Hackney Downs with a service for Enfield Town.

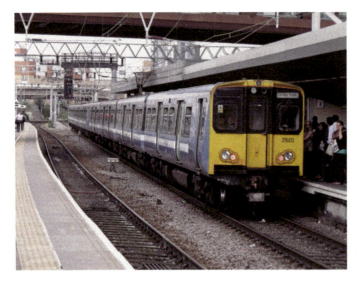

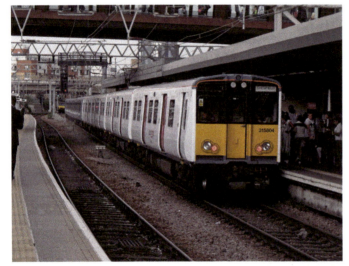

Four Class 315s were given a new style of headlights, two of these units were Nos 315812 and 315804. Both seen on the same day departing at different times for services for Gidea Park and Shenfield, No. 315812 has yet to receive the new Greater Anglia livery that has already been applied to No. 315804. Both of these units later transferred to London Overground.

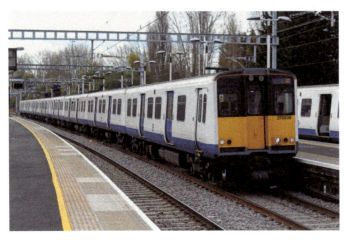

After transferring away from Greater Anglia to Transport for London in 2015, all the Class 315s allocated to the Shenfield–London Liverpool Street services received a new white and blue livery complete with an interior refresh. No. 315838 arrives into Shenfield after completing the 20-mile journey from the capital.

Greater Anglia's fleet of five Class 153 Sprinters would start to be refurbished

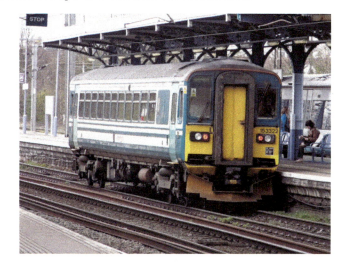

No. 153322, in full Anglia livery complete with Greater Anglia branding, is seen departing Ipswich with the hourly service to Felixstowe.

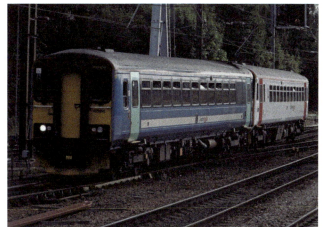

A before and after of the Class 153 refurbishment scheme is seen arriving into Norwich as No. 153314 leads No. 153322 into Norwich after working a service from Sheringham. As it was a Summer Saturday, these units would spend the day working as a pair to increase passenger capacity.

One of the first refurbished Class 153s was No. 153335, which sits in Ipswich yard between duties. Note the destination blind above the driver's window. This style of destination blind would remain on these units until they transferred to Transport for Wales.

The nine Class 156s would also receive a refurbishment as they were given an overhaul. The first one to receive this refurbishment was No. 156402, which was completed in November 2012. The long process of refurbishing units meant that the colourful mix of Central Trains, ONE and National Express-liveried Sprinters would eventually all become uniform.

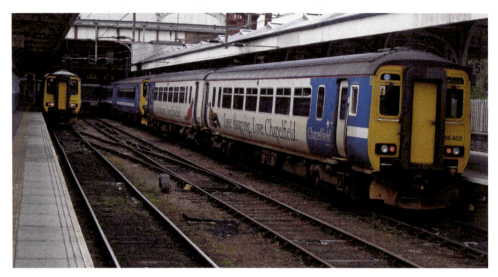

Until September 2012, No. 156402 wore a unique advertising livery for Chapelfield shopping centre, which covered the entire unit. Having just arrived into Norwich, it shares the platforms with Nos 156409 and 156416.

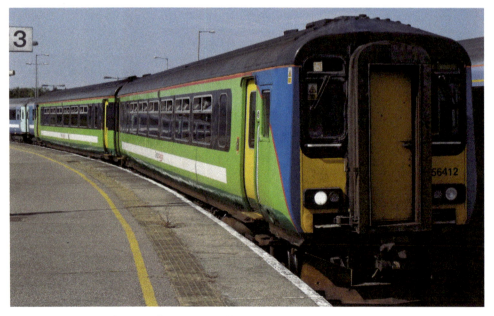

In 2005 a swap with Central Trains would see nine Class 156s come back to East Anglia. Some of these units arrived in the Central Trains green livery, which would remain until their refurbishment. No. 156412 was one of these units seen arriving into Great Yarmouth with a service from Norwich.

Greater Anglia: The First Ten Years 11

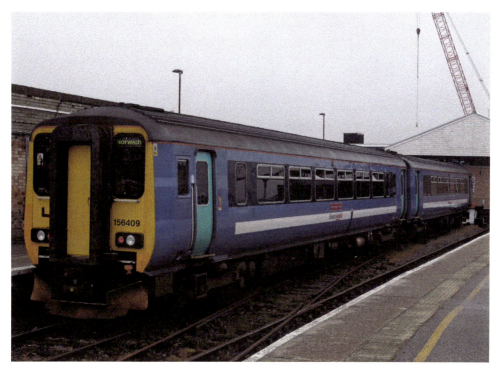

No. 156409 seen sitting at Great Yarmouth with a service for Norwich in former ONE livery. It was named *Cromer Pier Seaside Special* in 2009, which remained until it was removed in 2013.

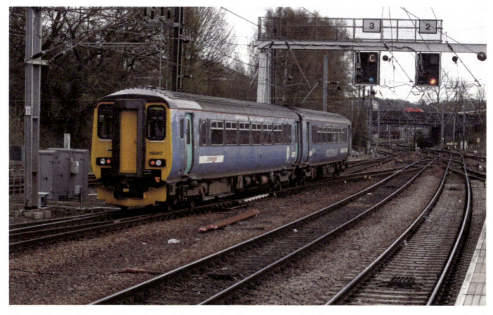

No. 156417 departs Norwich with a service for Lowestoft. The trailing carriage was involved in an accident on the Sudbury line in August 2010 after striking a slurry tanker, which caused significant damage. Its return to service sees it wearing part Greater Anglia and National Express East Anglia branding and part of the Bittern Line branding, which had been applied in 2007.

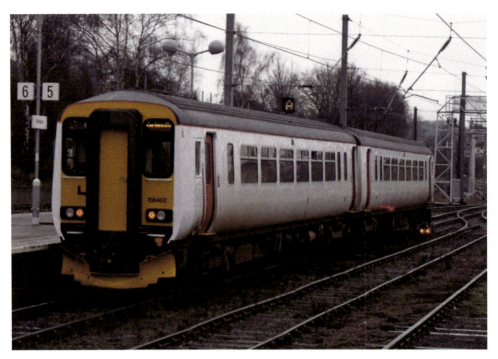

The first refurbished Class 156 was No. 156402. Still missing Greater Anglia branding, it departs a miserable Norwich with a service for Great Yarmouth. This livery would not be remaining white for very long.

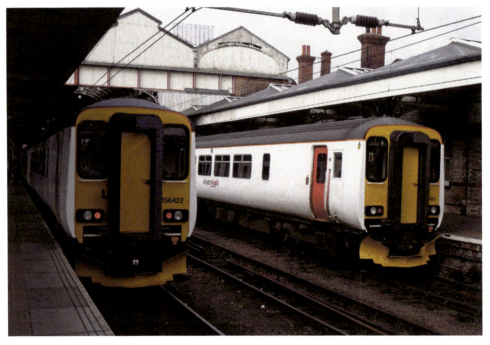

No. 156402 and newly refurbished No. 156422 sit at Norwich with services for Great Yarmouth and Lowestoft.

The Class 90s, Class 170 Turbostars (with the exception of No. 170208), Class 360 Desiros and Class 379 Electrostars would see no major changes throughout this period apart from getting a deep clean throughout and receiving the new Greater Anglia logo, with most receiving it on the interim white stripe left by National Express.

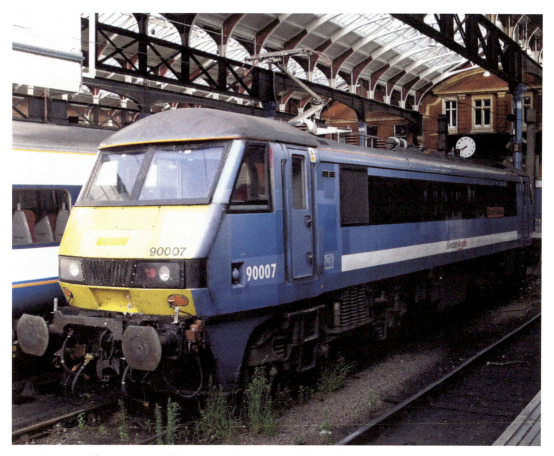

Occasionally it was possible to see a Class 90 stabled in the middle road at Norwich station. They could be seen here for a number of different reasons, with one of the main reasons being that they were out on a test run after receiving maintenance at the nearby Norwich Crown Point depot. No. 90007 sits in the centre road between duties.

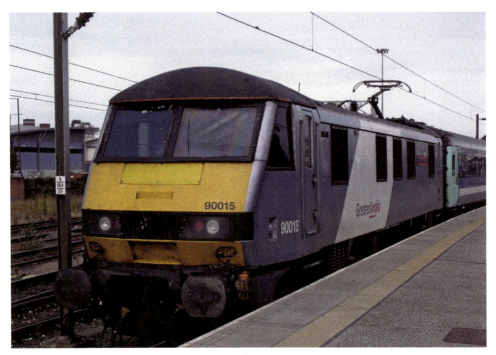

No. 90015 was one of three Class 90s that received the house colours of National Express during the National Express East Anglia years (Nos 90003 and 90008 being the other two). No. 90015 would keep these livery until Greater Anglia sent it away during the middle of 2015.

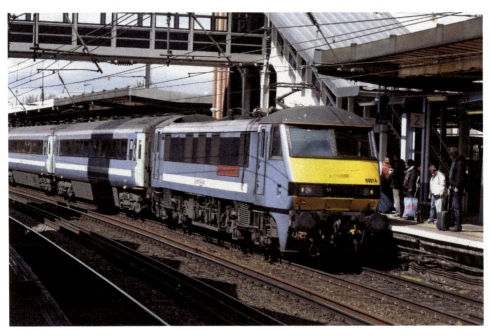

Only two months into service and Greater Anglia didn't take long to put their branding on their trains as No. 90014, complete with the then new Greater Anglia branding, arrives into Ipswich with a service for London Liverpool Street.

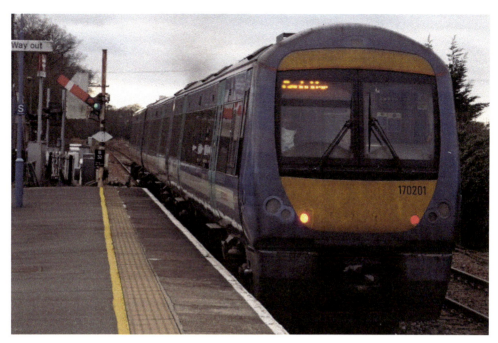

Above and below: One of Greater Anglia's first commitments when taking over was to deep clean all trains and stations. The Turbostars were in dire need of a cleaning with thick layers of filth all over the train as seen with No. 170201, seen departing Brandon with a service for Cambridge. Two months later No. 170201 is seen at the same location after being deep cleaned.

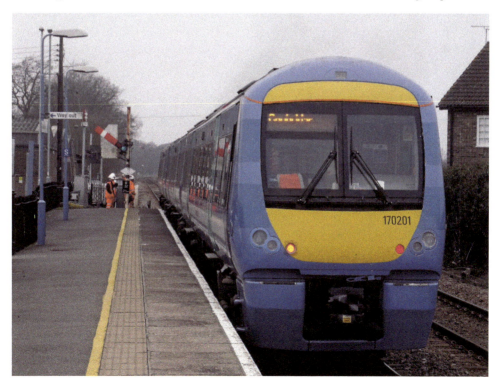

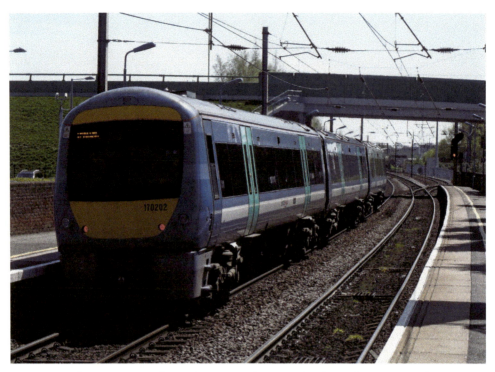

No. 170202 departs Stowmarket with a service for Ipswich. The Turbostars provide an hourly service between Cambridge and Ipswich via Bury St Edmunds.

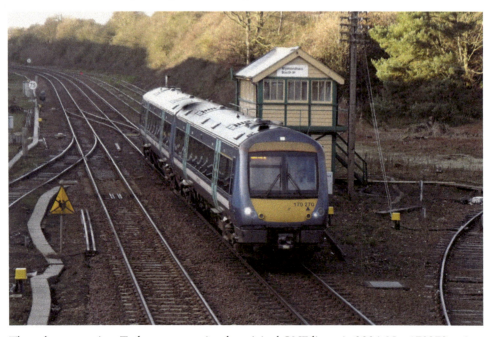

The only two-carriage Turbostar to receive the original ONE livery in 2004, No. 170270 arrives into Wymondham with a service for Norwich. After this image was taken this unit would carry this livery for another four years.

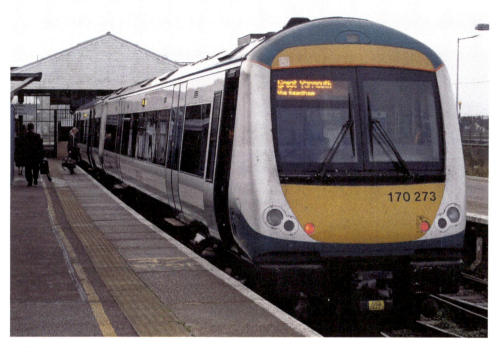

Still in full Anglia Railways livery, No. 170273 sits at Great Yarmouth with a service from Norwich. These services have a quick turnaround before heading back.

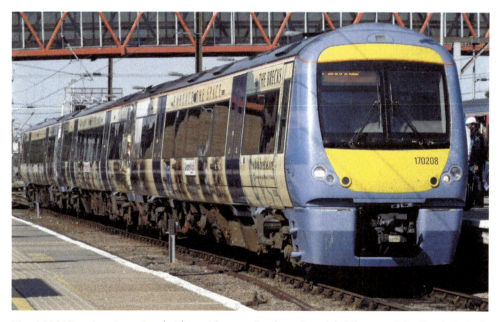

No. 170208 arrives into Cambridge with a service from Ipswich. The new 'The Brecks' vinyls had only recently (when this image was taken in August 2013) had been applied to this Turbostar in an attempt to attract more tourism onto the Breckland line. However, this was a short-lived venture and No. 170208 lost this branding when it was refurbished in 2017.

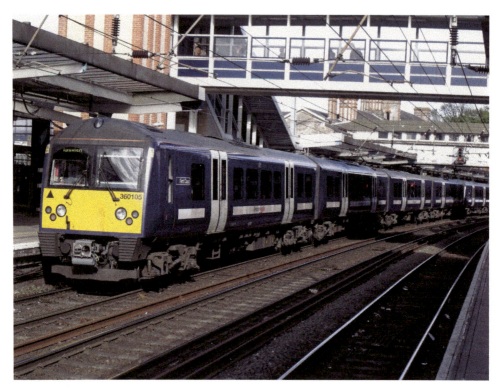

No. 360105 sits at Ipswich with a peak time service for London Liverpool Street.

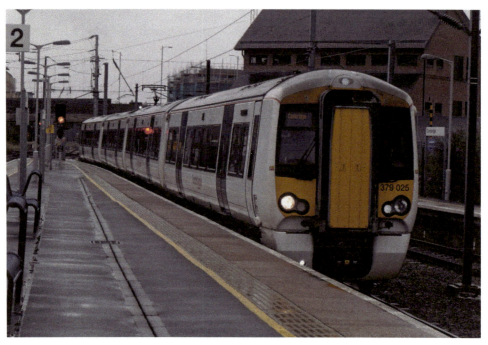

No. 379025 arrives in Cambridge with a service from London Liverpool Street. These units were a regular sight on these services during the weekend.

Meanwhile, the Class 317s and Class 321s were still receiving refurbishment during this period while the non-refurbished units carried the liveries of previous operators. The refurbished received a plain white livery; losing the franchise meant National Express did not apply their branding.

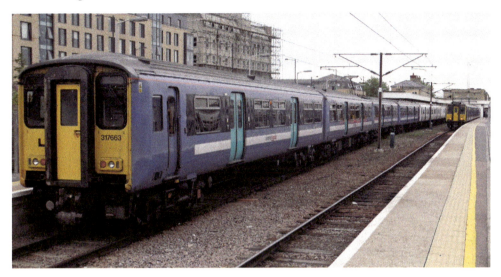

A variation of liveries at Cambridge as No. 317663, still in its old ONE blue colours, sits at the head of a London Liverpool Street service. Parked next to it is No. 317344, which would transfer to Greater Anglia in 2017.

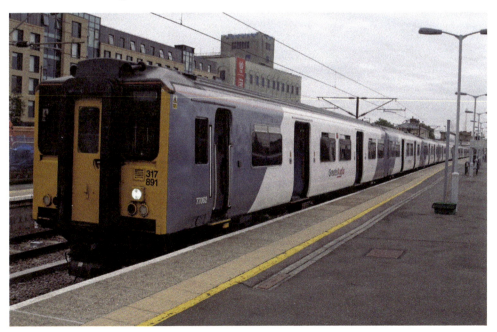

Ready for weekend travellers towards the capital, former Stansted Express Class 317 No. 317891 waits time at Cambridge with a service for London Liverpool Street. In 2015, No. 317891 would leave Greater Anglia and transfer over to London Overground.

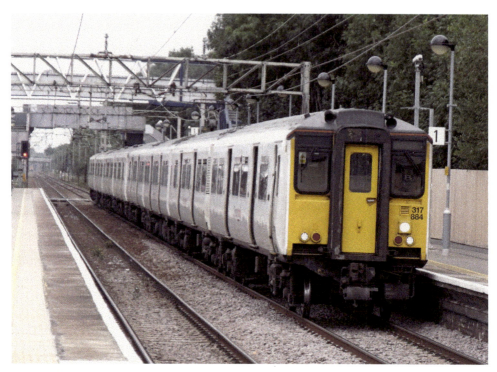

A pair of Class 317s lead by No. 317884 arrives into Cheshunt with a service from Hertford East heading towards London Liverpool Street.

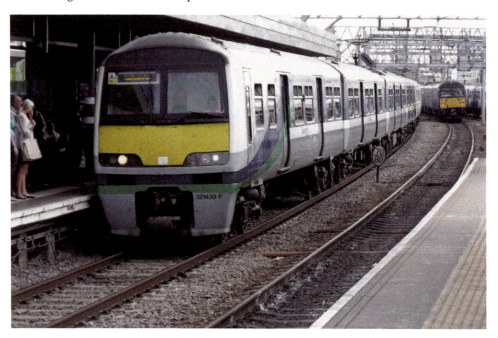

No. 321439 arrives into Stratford with a service for Southminster. Despite First Great Eastern going defunct in 2004, the livery still remains on No. 321439 eight years later. It would eventually end up in an all-over white livery.

This period of the Greater Anglia franchise would also see the Summer Saturday London Liverpool Street–Great Yarmouth services cease operating in 2014. These were made up of a Class 90-hauled set from London Liverpool Street to Norwich before a Class 47 would attach at Norwich and drag the entire train down to Great Yarmouth. On arrival at Great Yarmouth the Class 47 would run round the train and drag it back to Norwich before being uncoupled and the 90 set continuing to London Liverpool Street.

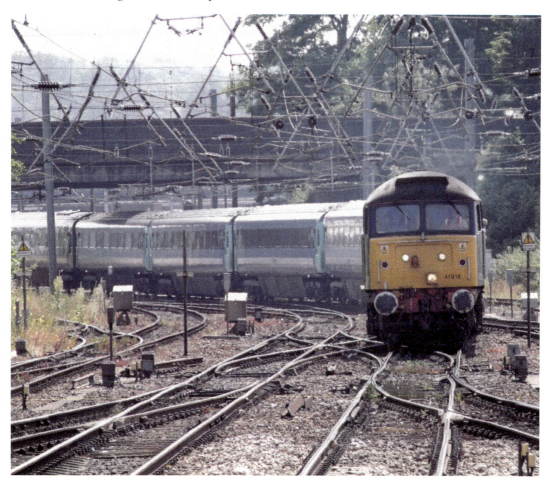

DRS Class 47 No. 47818 arrives into Norwich with the first dragged loco-hauled service of the day from Great Yarmouth.

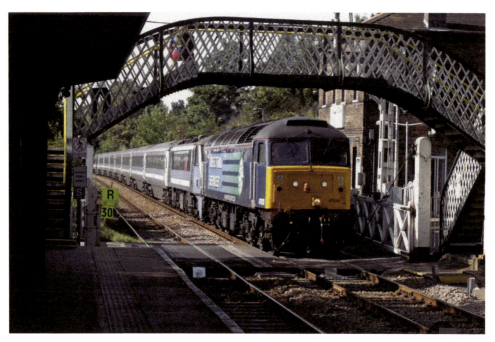

On a glorious sunny September afternoon, No. 47828 passes through Brundall with No. 90005 with the third and last service of the day to Great Yarmouth from London Liverpool Street. On arrival at Great Yarmouth, No. 47828 will run round the train and it will head to Norwich Crown Point ECS.

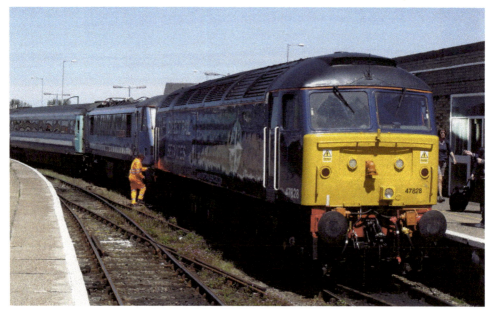

After arriving at Great Yarmouth, No. 47828 needs to be uncoupled and run round. This is done with a manually operated set of points, which are out of view to the right of the image. Once No. 47828 has run round it was coupled up to the 90 set and will push it further back into the platform before allowing passengers to board.

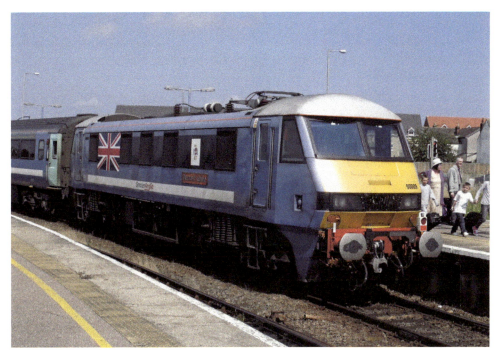

To save time the Class 90 is left coupled to the train and is also taken down to the coast, which allows for the unusual sight of an electric loco seen without any wires. No. 90009 looks out of place at Great Yarmouth as it sits in platform 2 without power.

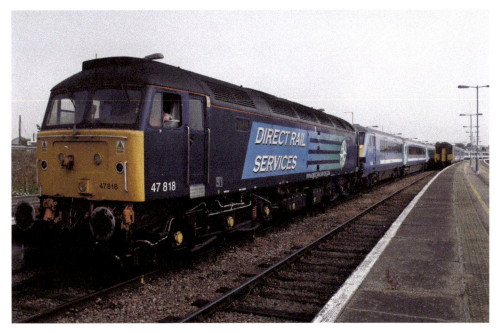

After successfully running round its train, No. 47818 sits at Great Yarmouth with a service for London Liverpool Street. This train will run non-stop from Great Yarmouth to Norwich via Reedham.

In March 2013 the short franchise that Abellio had originally been granted was extended through to October 2016. During this extension the company name changed slightly and the original Greater Anglia logo on their trains was replaced as they were rebranded Abellio Greater Anglia. This would remain in place until the start of the new franchise in 2016.

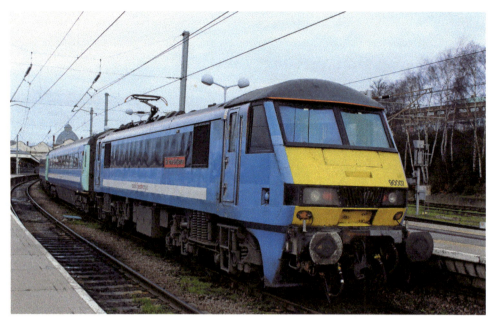

By January 2016, all but one of the Class 90s had received the new Greater Anglia livery. No. 90007, while waiting for departure for London Liverpool, is seen still holding onto the past in ONE blue.

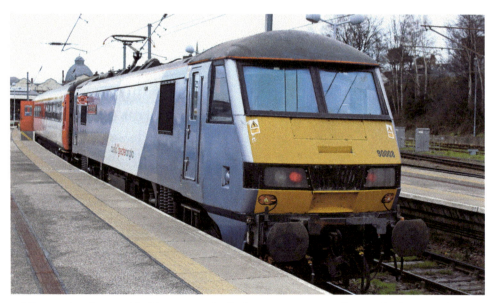

While wearing the new Abellio Greater Anglia logo No. 90008 still wore the former colours of National Express in 2016 as it waits time with a service for London Liverpool Street.

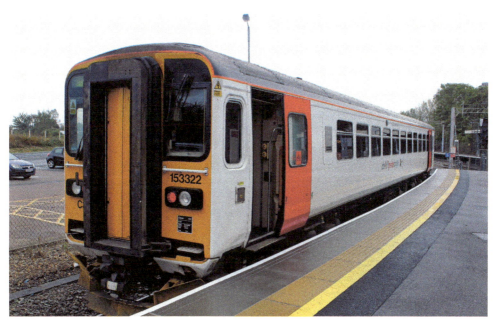

No. 153322 is seen at Marks Tey with a service for Sudbury. When Greater Anglia rebranded their trains in 2016, No. 153322 would continue to wear the then new Abellio Greater Anglia logo until it was de-branded in 2019.

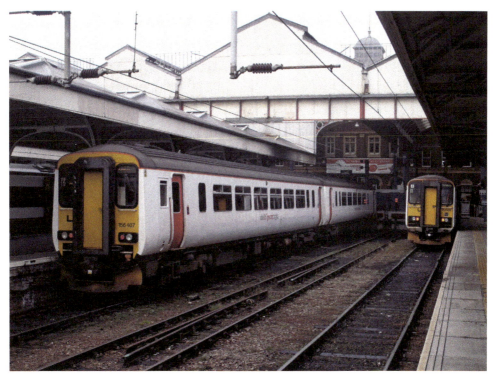

The Class 156s were given a fairly small Abellio Greater Anglia branding as seen applied to No. 156407, which is here at Norwich with a service for Lowestoft.

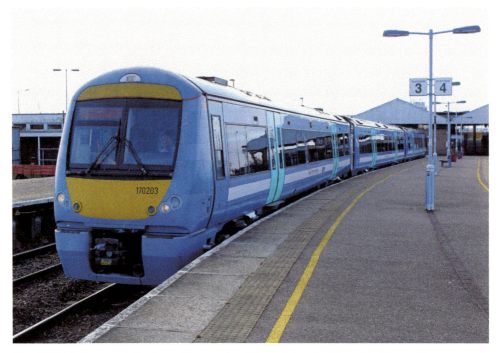

No. 170203 sits at a chilly Great Yarmouth with a service for Norwich. These diagrams were mainly covered by Class 156s; however, it wasn't unusual to see a Turbostar working this line during busy periods.

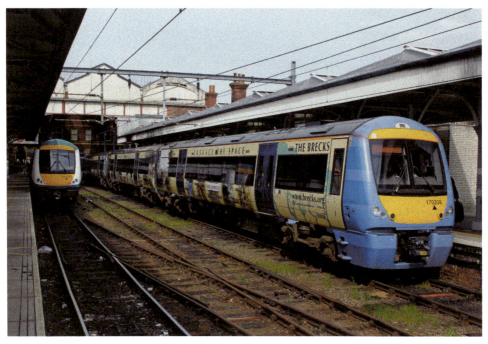

While No. 170273 sits in Norwich station with no booked service, No. 170208 spends the day working the Sheringham line.

Greater Anglia: The First Ten Years

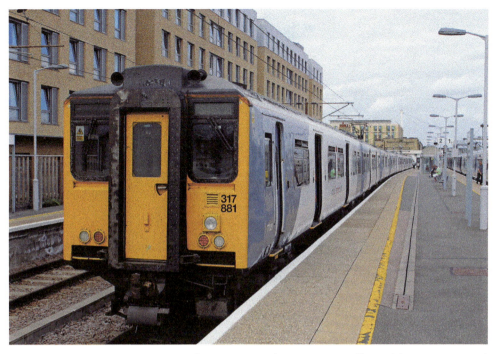

In summer of 2016, four years into the Greater Anglia era, it was still possible to see National Express East Anglia colours as the 317/8s were getting refurbished that year. No. 317881 is seen at Cambridge, yet to be treated to a new paint scheme and interior.

A recently refurbished No. 317508 sits in a gloomy and foggy Cambridge with a service for London Liverpool Street.

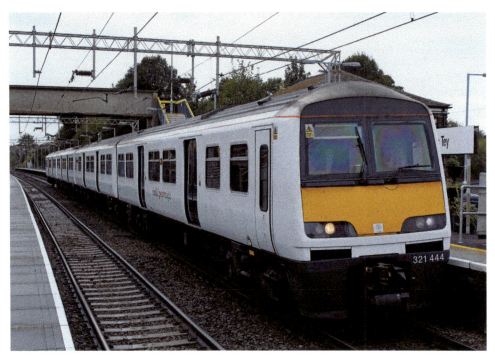

Above and below: Marks Tey station, located 5 miles south of Colchester, sees a regular service towards London Liverpool Street as it is served by both services to and from Ipswich and Clacton. No. 321444 sits at Marks Tey with a service for Clacton-on-Sea while No. 321316 is seen later in the day departing for London Liverpool Street. This unit would be one of the thirty Class 321s that would get a Renatus upgrade.

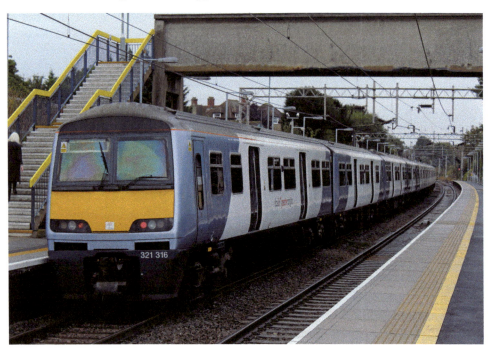

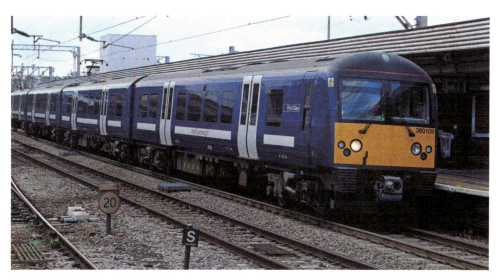

The hourly services between Ipswich and London Liverpool Street were shared between the Class 321s and Class 360 Desiros. No. 360109 arrives into Colchester with a service for Ipswich.

The new Abellio Greater Anglia logo would also be unveiled on the new refurbishment scheme for the Class 90s and Mk3 carriages, which underwent a new internal and external refurbishment. The first complete set of a Class 90 and rake of Mk3 carriages including the DVT was in service by May 2015.

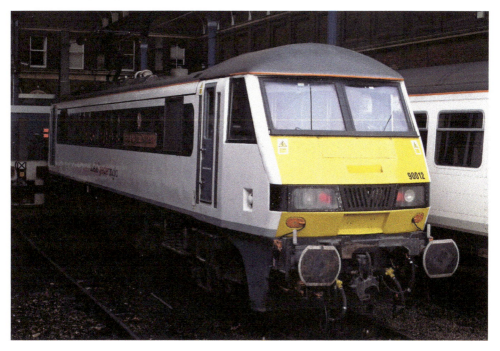

Another day and another Class 90 hiding away in Norwich station as No. 90012 sits in Norwich station awaiting its next duty. This loco was called *Royal Anglian Regiment* at London Liverpool Street in November 2007, name that would remain on the loco until May 2021.

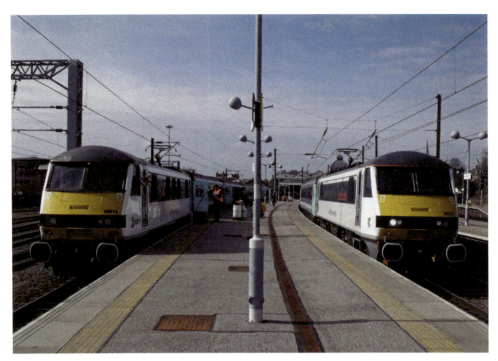

Above and below: In March 2015, despite the Class 90s wearing their new livery, it was still common to see a rake of Mk3 carriages still in the old 'interim' livery as Nos 90014 and 90012 are prepared for the journey to London Liverpool Street. By the start of the 2016 the Mk3s had been also received the new livery and started to match the Class 90s, as seen with Nos 90009 and 90004.

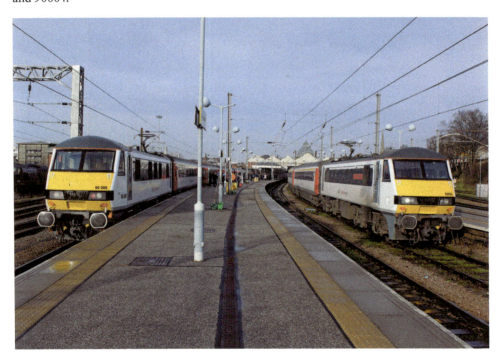

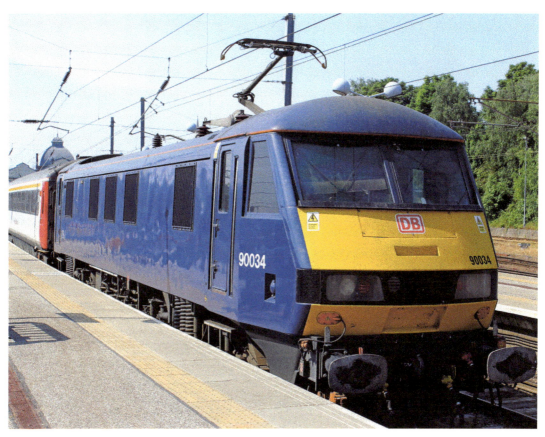

During the refurbishment process of the Class 90s, to ensure a full service was being maintained on the Great Eastern Main Line, No. 90034 was hired in from DB Cargo. When working with refurbished white Mk3 carriages it was very noticeable in its dark blue livery.

In 2013, to keep services running despite a shortage of available DMUs, Greater Anglia started operating a loco-hauled service between Norwich, Great Yarmouth and Lowestoft. This quickly gained the name of the 'Short Set' and became very popular with the rail enthusiasts in the area. It originally started with Class 47s and Greater Anglia Mk3 carriages, which later changed to DRS Mk2s and Class 37s in 2015, which would remain until the arrival of the new trains in 2019.

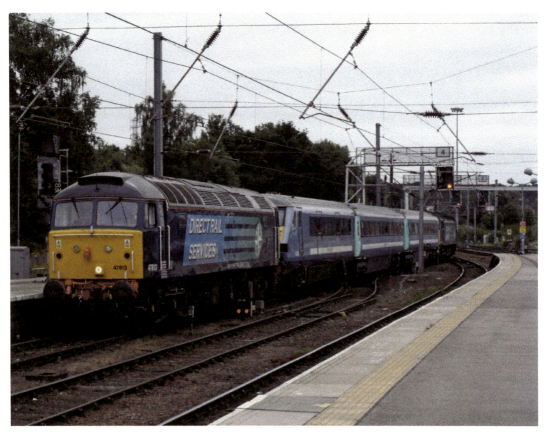

DRS Class 47 No. 47813 arrives into Norwich with a Short Set service from Great Yarmouth. No. 47818 was on the rear of the train for the journey back to the coast.

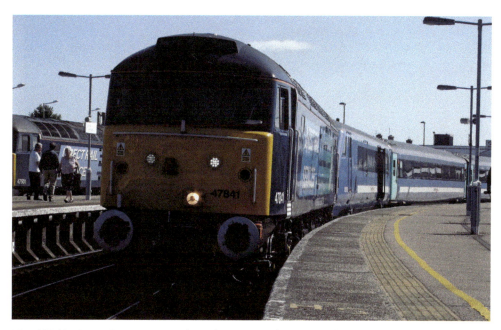

No. 47841 sits at Great Yarmouth with a service for Norwich. The Short Set was operated instead of the loco-hauled drags on this day in August 2013. This was because of a railtour that was operating from Crewe to Great Yarmouth with Nos 47501 (seen on the left), 47802, 37423 and 37605.

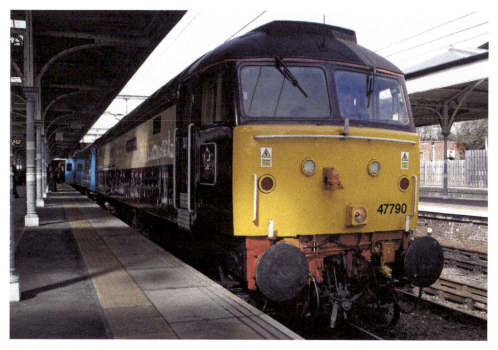

Northern Belle Class 47 No. 47790 operated the Short Set in early 2015 as it awaits departure with a service for Lowestoft. The Greater Anglia Mk3s had been replaced with the DRS Mk2s by this time.

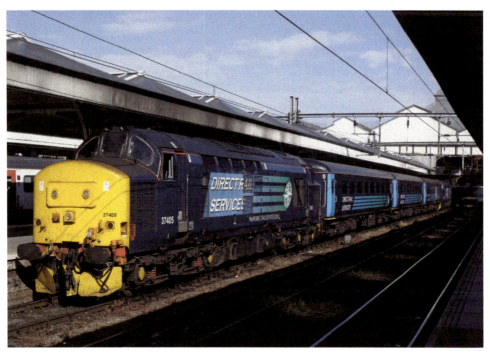

Above and below: By June 2015, the Class 47s had gone and the Class 37s had arrived. No. 37405 sits at Norwich with a service for Great Yarmouth, and No. 37425 sits at Great Yarmouth with a service for Norwich. These services had the same stopping pattern as the units they were covering.

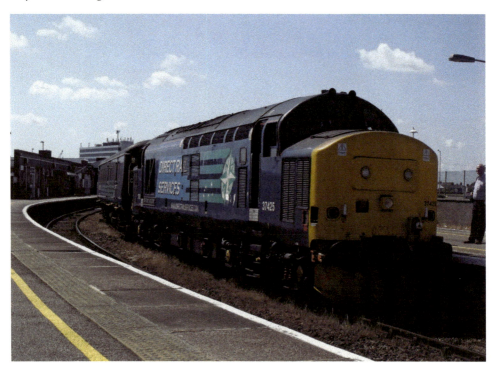

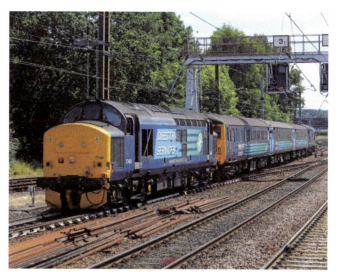

No. 37405 arrives into Norwich with an old East Anglian regular as Driving Brake Standard Open (DBSO) No. 9705 makes up part of the rake. This DBSO was transferred in the 1980s when the GEML was electrified and would remain here until being replaced with a Mk3 DVT in 2003 and being transferred to DRS in 2015.

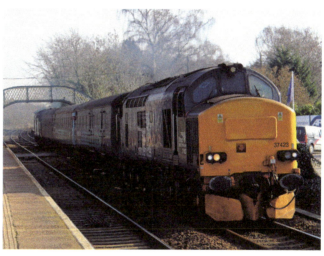

A number of Class 37/4s operated on the Short Set. One was 37423, seen departing Brundall with a service for Norwich. Out of shot on the left is one of the new colour aspect signals that will replace the semaphores as part of the Wherry Lines signalling upgrade scheme.

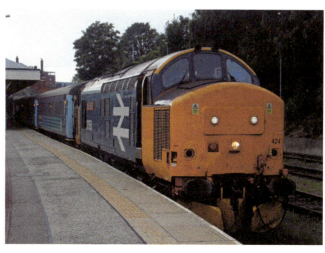

No. 37424 sits at Norwich with a service for Great Yarmouth. A few days after this image was taken the Short Set was removed from regular service and placed on standby.

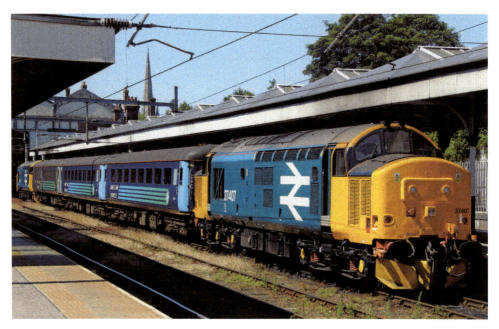

DRS painted some of their Class 37/4s into retro liveries harking back to the British Railways era with large logos making a comeback. Nos 37407 and 37409 were two of the locos that received this eye-catching livery as they sit at Norwich in the summer sunshine with a service for Great Yarmouth.

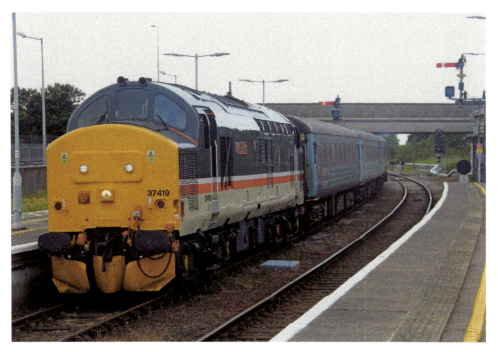

No. 37419 was another DRS Class 37 to receive a retro livery, this time receiving InterCity colours; albeit without the InterCity branding. Shortly after repainting it wasn't long before it appeared on the Short Set as it arrives into Great Yarmouth.

A second Short Set arrived in July 2016 as Greater Anglia suffered more unit issues as No. 170204 had been involved in an accident and the Class 156s were getting upgrades. This Short Set was formed again of three Mk2 carriages but instead the locos used were DRS Class 68s, which again appealed to the rail enthusiasts.

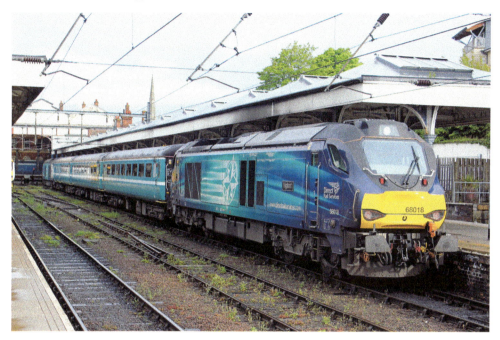

Above and below: No. 68018 sits with No. 68003 at Norwich with a rake of former Anglia Railways Mk2s with a service for Lowestoft. The set is later seen at Lowestoft preparing for departure with a returning service.

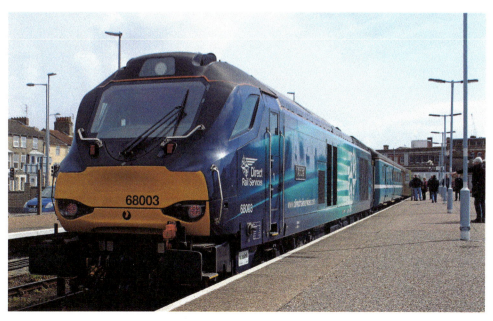

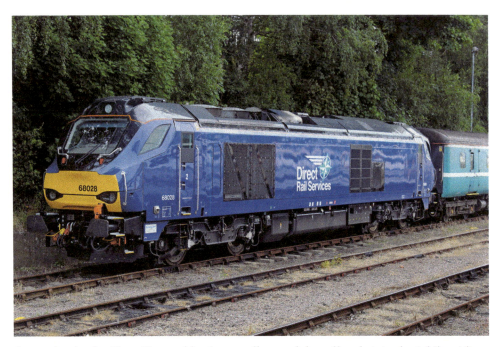

On weekends, the Class 68s would enjoy a well-earned day off and sit in the Jubilee sidings before heading to Crown Point for maintenance, wearing just an all-over blue livery. This loco was destined to head to First Transpennine Express and wear their livery. In the meantime, No. 68028 rests at Norwich before heading to Crown Point.

Before the beginning of the new franchise, one new station opened on the Greater Anglia network, Lea Bridge between Stratford and Tottenham Hale on the West Anglia Main Line.

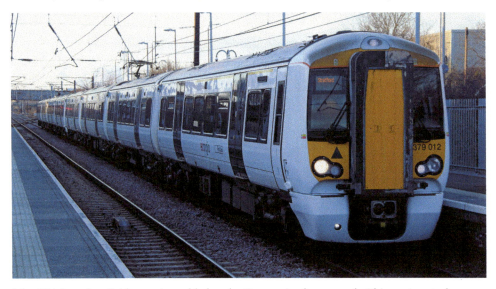

May 2016 saw Lea Bridge station added to the Greater Anglia network. This station sits between Stratford and Tottenham Hale and is served by services from Bishops Stortford and Meridian Water towards Stratford. No. 379012 arrives with No. 379015 with a service for Stratford.

The Later Years: 2016–Present Day

In 2016, after running two short-term franchises in the meantime, it was finally time for Greater Anglia to shine as they had won the nine-year East Anglian franchise. Upon winning the franchise, they made a lot of commitments for the East Anglia region. Some of these involved:

- Extension of some existing services, such as Norwich–Cambridge becoming Norwich–Stansted Airport.
- The introduction of a new Norwich in 90 service running between Norwich and London Liverpool Street, with Ipswich being reachable in sixty minutes.

The biggest change, however, for Greater Anglia was that they were to going to embark on the largest change to their rolling stock, which would change the entire look of East Anglian railway network as they announced that they were going to replace all their trains with fifty-eight new trains from Stadler and 111 new trains from Bombardier.

The new fifty-eight Stadler-built trains were to arrive as thirty-eight new bi-mode units allocated as Class 755 FLIRTs in three- and four-carriage formations and also twenty, twelve-carriage EMUs, which still came under the FLIRT banner but were allocated as Class 745s.

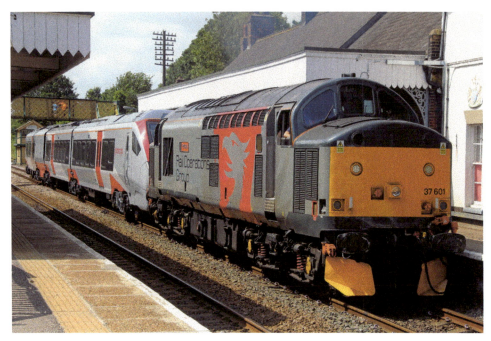

Above and below: The Mid Norfolk Railway was used to store the FLIRTs when they arrived due to limited space in Norwich Crown Point. Class 37s were used to drag them back and forth when required. As it slowly pulls off the Mid Norfolk Railway, No. 37601 drags Nos 755422 and 755420 back to Crown Point depot for their introduction into service.

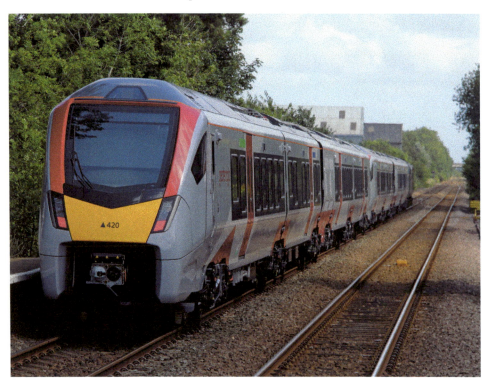

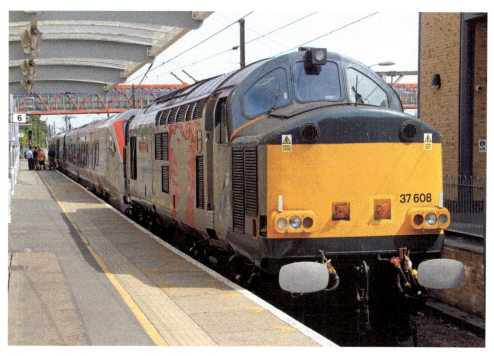

Above and below: It wasn't long before the new FLIRTs were being shown off. Given that they were the first of their kind in the UK, it wasn't long before they started to attract attention. No. 755406 sits at Cambridge with the assistance of No. 37608 on the front.

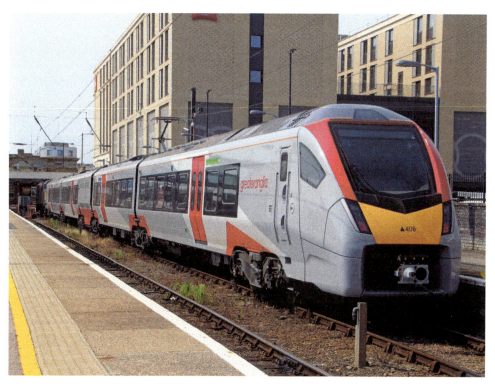

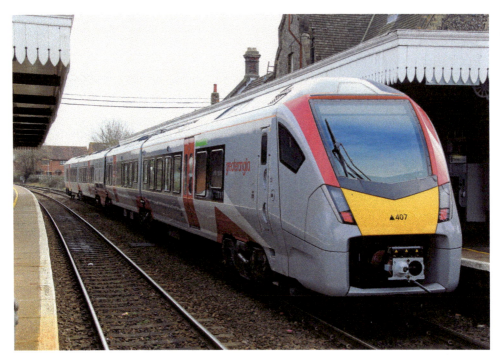

The Class 755s FLIRTs were regularly tested each day to ensure that they were ready before they were released into traffic on a test run. No. 755407 awaits departure from Thetford with a test run back and forth to Norwich.

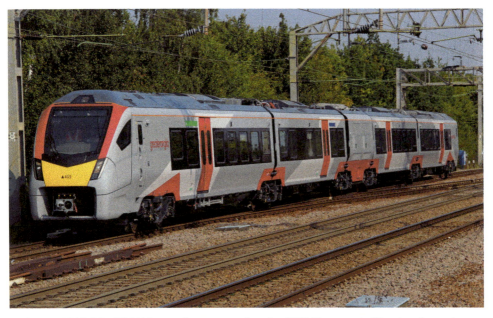

In August 2019, No. 755415 was chosen to undertake AWS (Automatic Warning System) tests, which would see a FLIRT break new ground by travelling on the Clacton-on-Sea and Harwich branches. Despite a FLIRT being cleared to go down the Clacton-on-Sea line, they would not serve this line when the fleet went into traffic.

Greater Anglia: The First Ten Years

As part of the grand unveiling of the new Class 755 FLIRTs, a sand sculpture was made of the train alongside a hare, which would later go onto become the mascot for Greater Anglia. In January 2022 it is still standing, despite some minor damage to the hare.

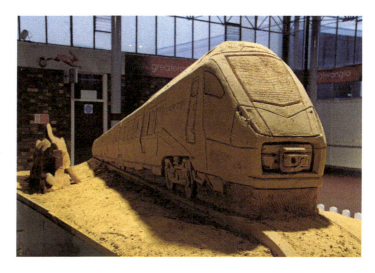

The new FLIRTs would bring an end to loco-hauled trains in East Anglia. They would replace the 90 sets on the Great Eastern Main Line and the Class 37-hauled 'Short Set' on the Wherry Lines. In May 2019, Greater Anglia ran a charity railtour 'The EACH Express 3', utilising Nos 37405 and 37409, which departed Norwich and would make its way to London Liverpool Street via Thetford, King's Lynn, before reversing and heading down the WAML followed by a non-stop run to Norwich on the GEML. Not only was this a railtour run for a very worthwhile cause, it was also seen to some as a farewell to the Class 37s, which had been operating in East Anglia since 2015.

A year previous Greater Anglia operated a very similar charity railtour utilising Nos 68001 and 68034, which covered the line between Norwich and Ely return before heading to London Liverpool Street via the GEML.

Greater Anglia ran a number of charity railtours across their network called 'The EACH Express', with all the proceeds going to EACH (East Anglia's Children's Hospices). In 2017 it was the turn of 'The EACH Express 2', which utilised a complete rake of Mk3 carriages with Nos 68001 and 68034. Seen on the Norwich–London leg of the trip, No. 68001 passes non-stop through Ipswich on the middle line.

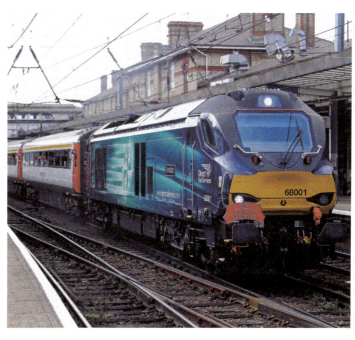

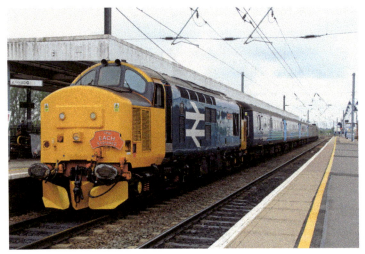

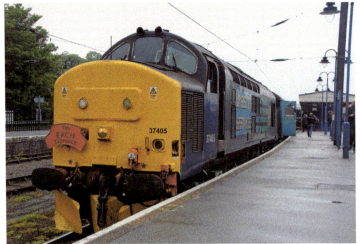

Two years later, Greater Anglia did another railtour, this time suitably called 'The EACH Express 3'. This was made up of five DRS Mk2 carriages with a DRS Class 37 on each end (Nos 37405 and 37409). This tour went places where loco-hauled trains had long since gone, such as King's Lynn via Ely and the West Anglia Main Line via Cambridge and Broxbourne, before heading back to Norwich via London Liverpool Street non-stop. No. 37405 sits at King's Lynn before the journey to London Liverpool Street. No. 37409 sits at Ely while the driver changes ends and also at London Liverpool Street to form the leg to Norwich.

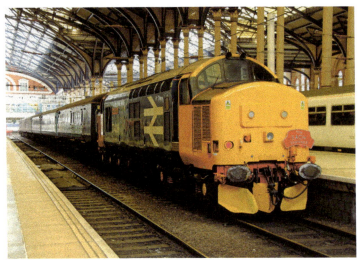

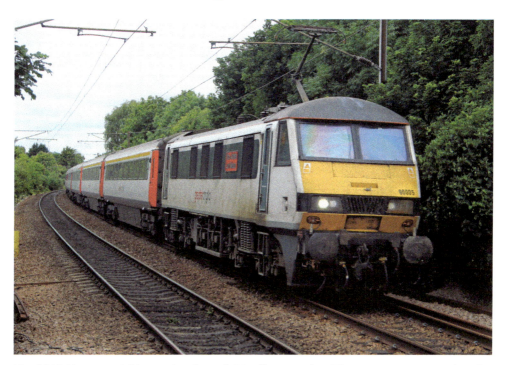

No. 90005 is seen quickly passing through Needham Market. These sets never stopped at this station, with passengers needing to head to the following station of Ipswich to board the train towards London Liverpool Street.

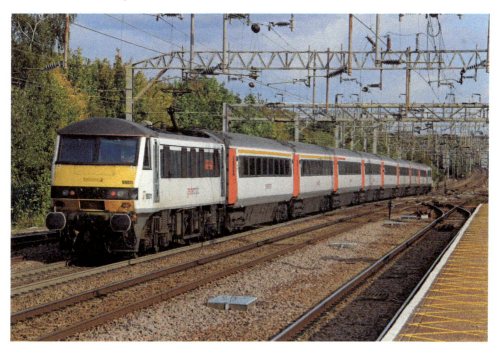

After completing its station stop, No. 90011 is seen pushing its train out of Colchester towards Manningtree with a service for Norwich.

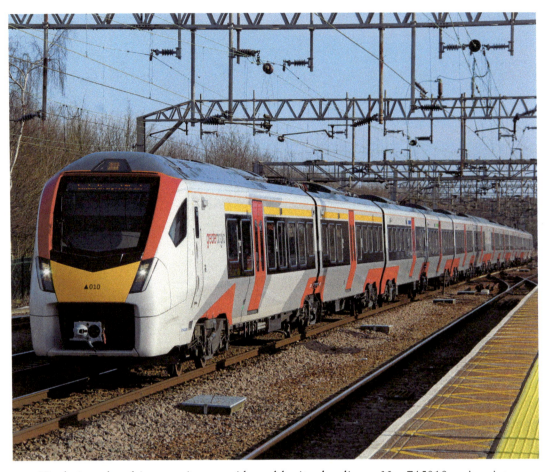

Newly introduced into service, as evidenced by its cleanliness, No. 745010 arrives into Colchester with a service for London Liverpool Street.

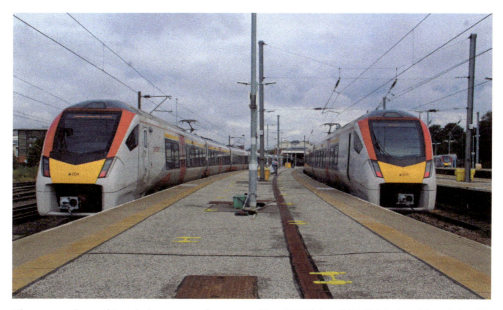

The new order making their presence known as Nos 745004 and 745005 sit at Norwich with services for London Liverpool Street.

The 111 new trains from Bombardier are part of the popular Aventra fleet, which have already seen work in London for both Transport for London and London Overground. These new units, which have been allocated as Class 720s, were to be formed of twenty-two ten-carriage units and eighty-nine five-carriage units. However, in late 2020 it was announced by Greater Anglia that the twenty-two ten-carriage Aventras were going to be built as five-carriage units instead.

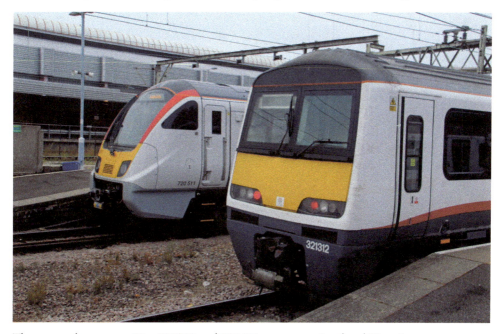

The past and present as Nos 321312 and 720511 are seen at Southend Victoria.

With new trains on the horizon, it didn't stop Greater Anglia pressing with more refurbishment schemes for their current stock. Their twelve Class 170 Turbostars were to receive an internal and external overhaul, which saw them repainted into the Greater Anglia livery.

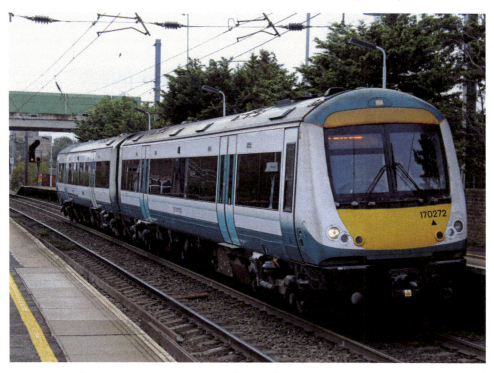

Above and below: The years are starting to show and refurbishment is needed on Nos 170271 and 170272 as their Anglia Railways livery starts to look very worn.

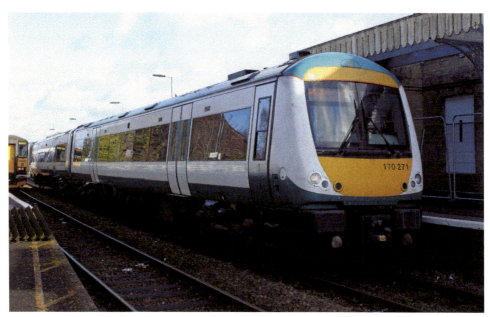

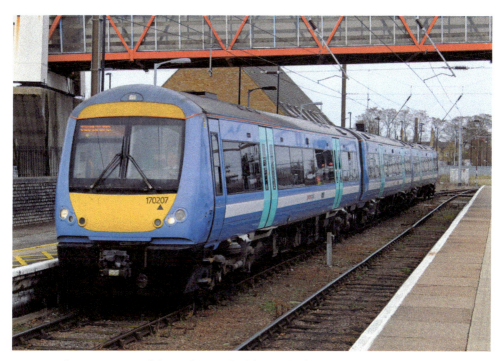

By November 2017 most of the Turbostars had been refurbished, which meant spare parts were in the new colours. No. 170207 arrives into Cambridge sporting two black coupling surrounds, which clashed with the blue livery.

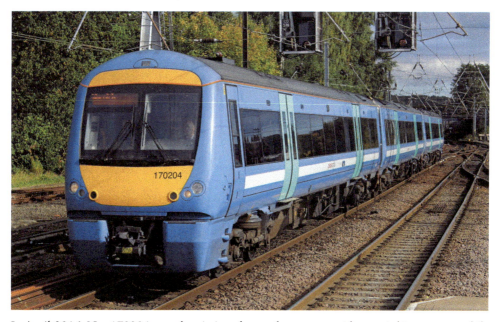

In April 2016, No. 170204 was the victim of an unfortunate accident as it hit a tractor while working a service to Cambridge. The entire unit was badly damaged, especially the leading cab. A year later it returned after repairs at Kilmarnock. The rebuilt cab is seen leading into Norwich with a service from Cambridge.

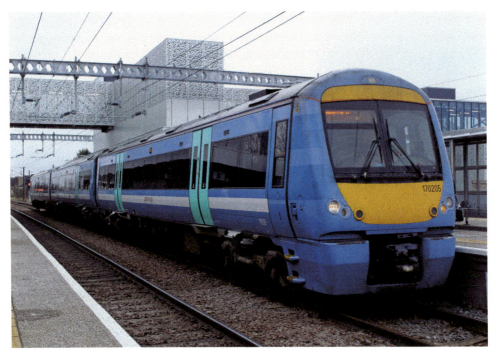

When No. 170205 at Cambridge North was seen in December 2017 it was both the last three-carriage Turbostar to be refurbished and it was the last unit to still wear the ONE blue livery. By March of the following year No. 170205 would receive the Greater Anglia livery.

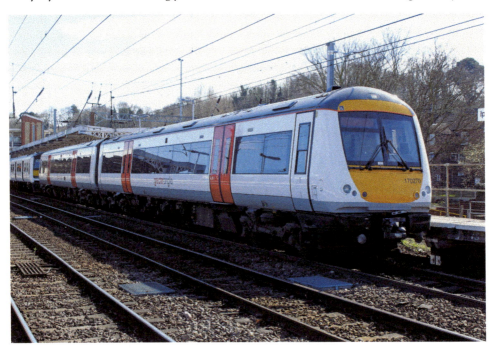

No. 170270, seen at Ipswich in its new livery after arriving from Peterborough, was the first Turbostar to go through a refurbishment that would eventually be carried out on the rest of the fleet.

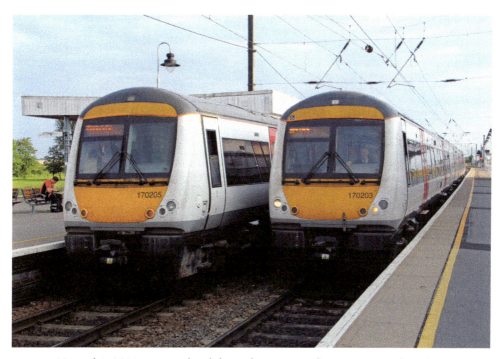

Nos 170205 and 170203 meet at Ely while working services between Norwich and Cambridge.

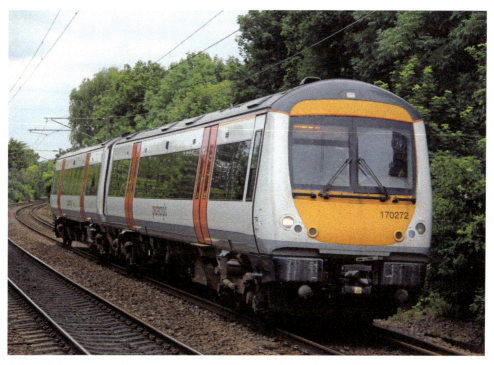

When Turbostars such as No. 170272 are allocated Peterborough–Ipswich diagrams they run non-stop between Stowmarket and Ipswich, which allows the Turbostars to reach their maximum design speed of 100 mph.

One of the first franchise agreements came to fruition on 20 May 2019, when an immaculate No. 90001 formed the very first 'Norwich in 90'. Calling at Ipswich and London Liverpool Street only, this service marked a new beginning for high-speed services between Norwich and London, which still runs to the present day with the Class 745 FLIRTs now operating the service.

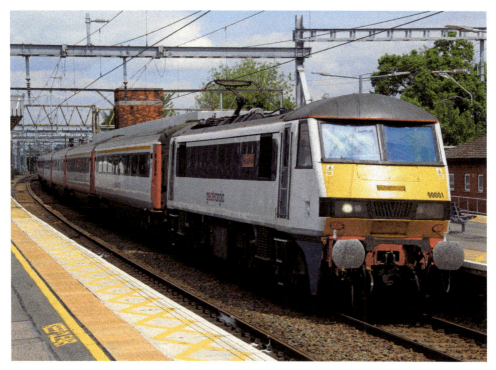

Seen a few days after its inaugural 'Norwich in 90' run, which saw the train arrive into London Liverpool Street early, No. 90001 is back to normal passenger duties passing through Ingatestone with a service for Norwich.

On 29 July 2019, the first Class 755 FLIRT (No. 755410) came into traffic working Wherry Line services. By July 2020 all thirty-eight of the Class 755 FLIRTs had entered into service and, because of more and more FLIRTs coming into traffic, it wasn't long before the branding on the DMUs was starting to disappear in preparation for the trains to be transferred to their new operators.

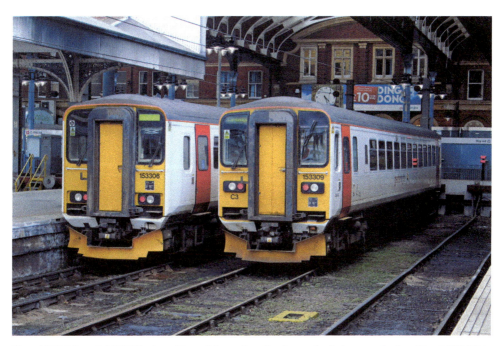

Nos 153306 and 153309 sit at Norwich as they both await their next duties. No. 153309 is displaying its cab when it was originally built as a Class 155, whereas No. 153306 shows the rebuilt cab when it was reformed into a Class 153.

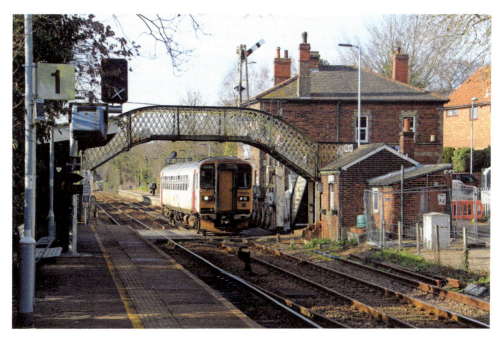

A scene that was due to completely change at the turn of the new decade. The soon to be replaced No. 153309 departs Brundall with a service for Lowestoft. The new signalling had been installed, which would replace the semaphore signalling, and was awaiting commissioning. The manually operated level crossing would also be replaced as it would become an automatic one.

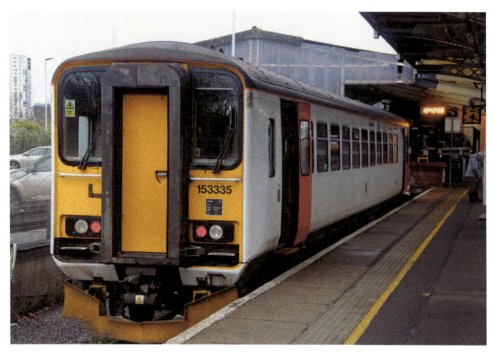

A full de-branded No. 153335 sits at Ipswich with a service for Lowestoft.

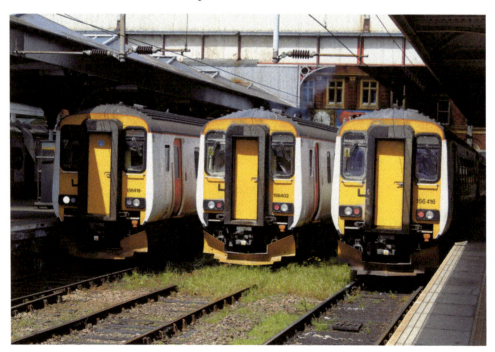

A full house at Norwich as Nos 156419 and 156416 work their various services, with No. 156419 departing for Sheringham and No. 156416 waiting to form the next service for Great Yarmouth. Meanwhile No. 156402 sits in the centre road as a spare unit to be used later in the afternoon.

Greater Anglia: The First Ten Years 55

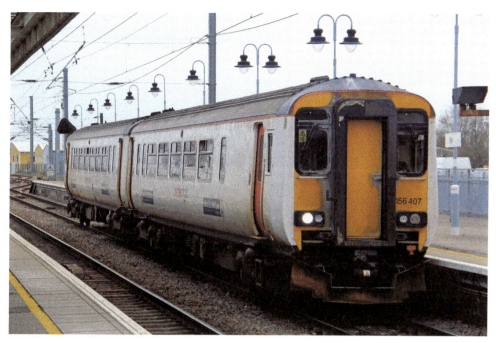

This page and next page: In 2016, Nos 156407, 156409, 156412 and 156417 were all chosen to advertise four different branch lines on the Greater Anglia network. No. 156407 advertises the East Suffolk Lines, No. 156409 advertises the Wherry Lines, No. 156412 advertises the Gainsborough Line, and No. 156417 advertises the Bittern Line. Despite the branding they aren't permanently allocated to these lines.

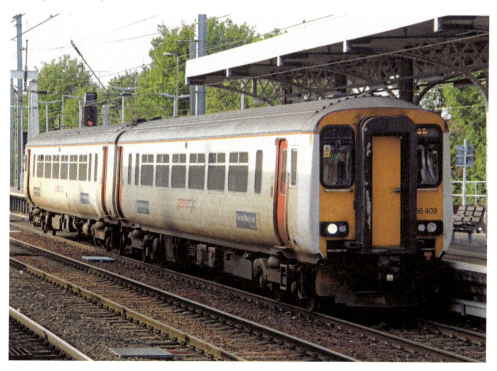

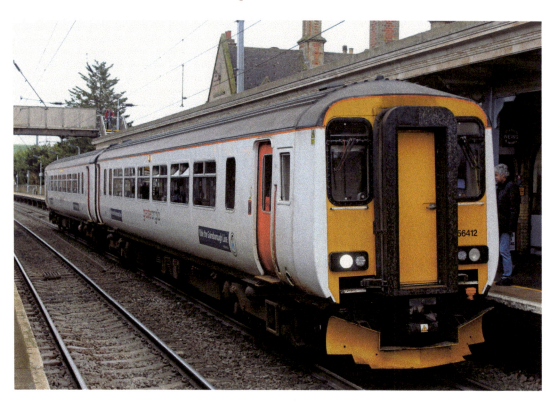
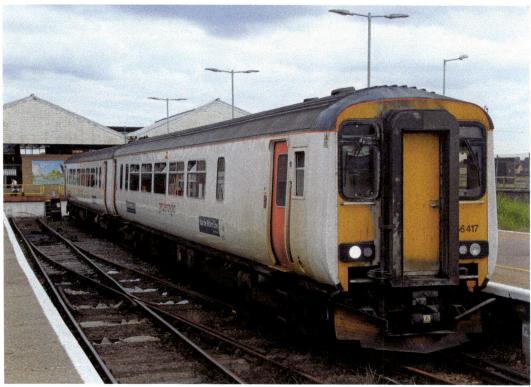

Transfer to East Midlands Railway is imminent for No. 156416. Before transferring, the number was unsubtly changed to No. 156916, which was due to the onboard Passenger Information Systems not being compatible with the software installed on EMR's home fleet of Class 156s.

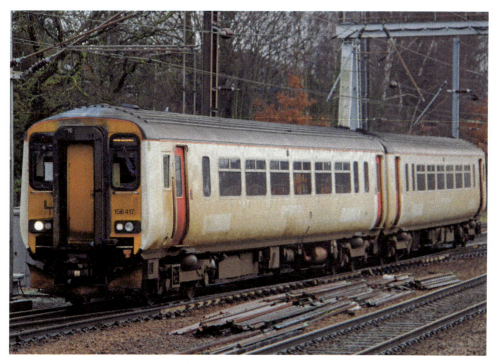

Complete devoid of both Greater Anglia and Bittern Line branding, No. 156417 arrives into Norwich with a service from Sheringham.

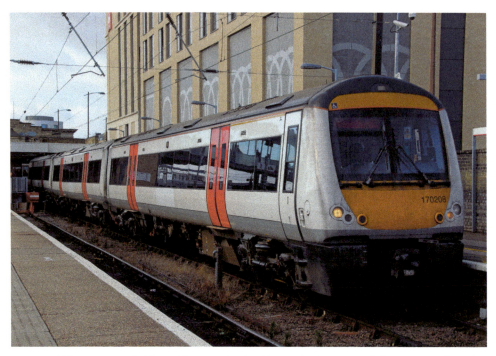

No. 170208 sits at Cambridge with a service for Norwich. On some of the units, such as this one, it wasn't too difficult to identify where the Greater Anglia branding was originally applied.

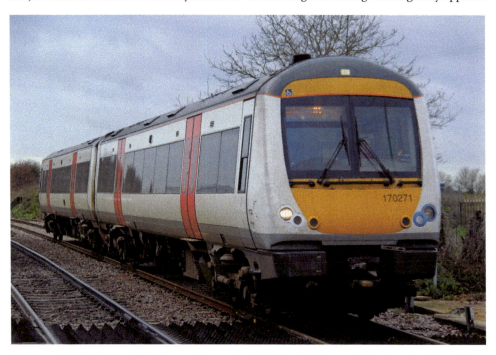

By the end of 2019, No. 170271 was Greater Anglia's final Turbostar left in East Anglia, arriving into Westerfield with a service for Lowestoft. Due to issues with the FLIRTs it would leave in February 2020 for Wales.

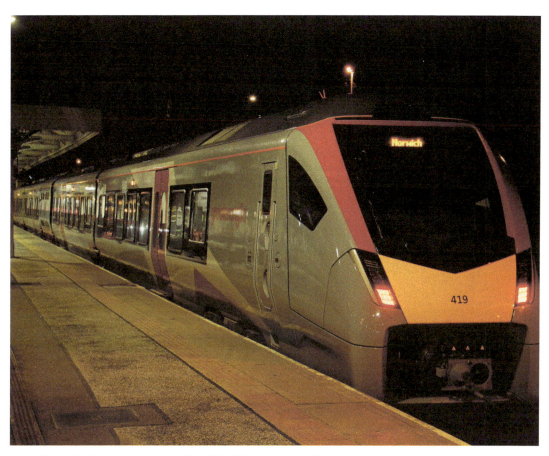

The night has drawn in but No. 755419 is far from finished for the day as it waits time at Norwich before departing with a service for Cambridge.

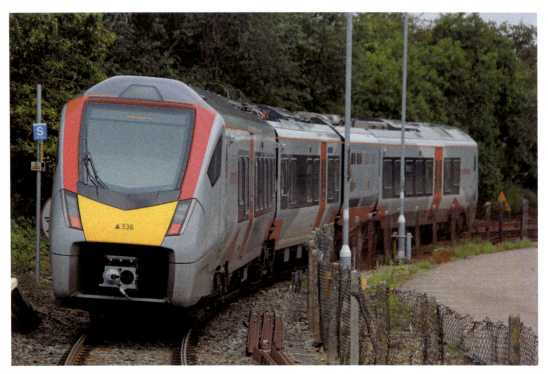

Above and below: Two lines that received an upgrade with the introduction of the FLIRTs were the Felixstowe and Sudbury lines, which operated with a Class 153 Sprinter. The minimum was now always three carriages. No. 755336 departs Marks Tey with a service for Sudbury and No. 755329 sits at Felixstowe with a service from Ipswich.

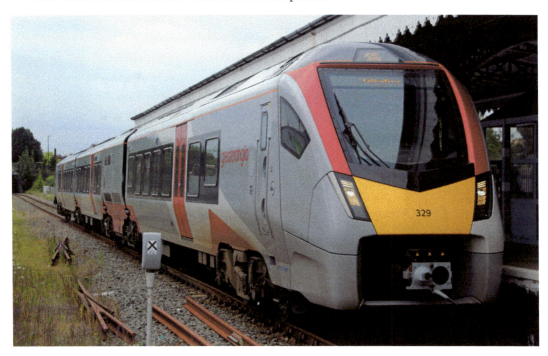

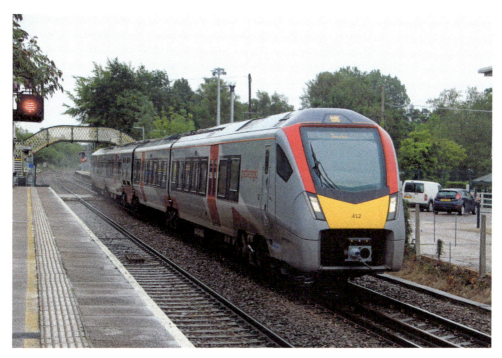

No. 755412 departs Brundall with a service for Norwich. By the summer of 2020 all of the new signalling on the Wherry Lines had been installed and was in full operation.

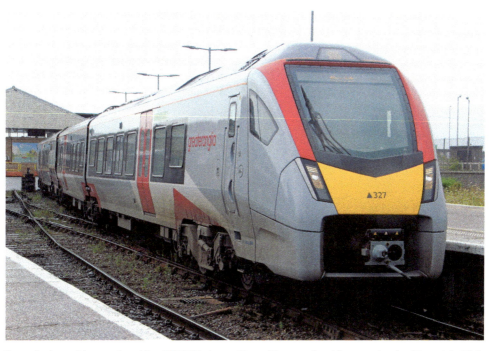

In typical seaside weather, No. 755327 sits at Great Yarmouth with a service for Norwich. This Class 755 FLIRT is a vast difference in terms of noise and size compared to the much older Short Sets and Class 153/156 Sprinters that ran previous to this.

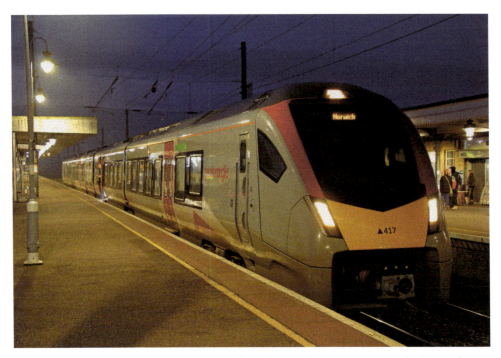

Unusually in platform 2, No. 755417 sits at Ely with an early morning service for Norwich.

This was followed by the first Class 745/0 (No. 745007) coming into traffic on the Great Eastern Main Line in January 2020 and the first Class 745/1 (No. 745103) coming into traffic on the Stansted Airport services on 28 July 2020. After this date, as more 745/0s and 745/1s became available, they were dispatched onto both the GEML and WAML and became a common sight.

Greater Anglia: The First Ten Years 63

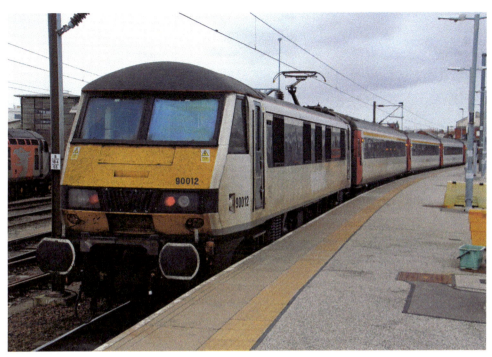

Above and below: The removal of Greater Anglia branding on the loco-hauled 90 sets on the GEML resulted in some different images as some of the consist had branding and some didn't. One example was No. 90012 at Norwich, which had been de-branded with the first Mk3 coupled behind it. Another scene at Ipswich shows No. 90015 de-branded, but hauling a complete rake of branded Mk3s.

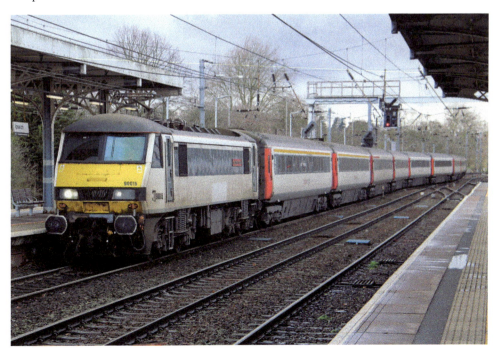

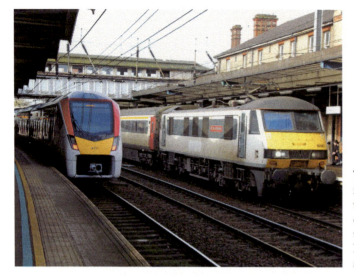

The Class 745s were slowly introduced into traffic throughout 2020. This allowed opportunities to see the new trains with their predecessors as Nos 745007 and 90007 meet at Ipswich.

28 July 2020 was the first day of Class 745/1s on London Liverpool Street–Stansted Airport services. These would eventually replace the Class 379s that were currently operating these services. No. 745108 is seen at London Liverpool Street lurking in the darkness with No. 745103, which is later seen at Stansted Airport before heading back to London Liverpool Street.

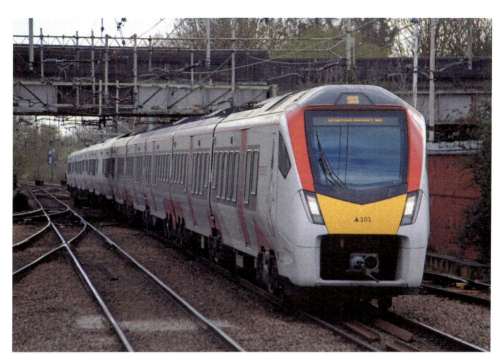

No. 745101 passes Broxbourne with a service for Stansted Airport. These services run a fast and frequent service between the airport and the capital with trains departing every thirty minutes.

Down in numbers but not completely out as a Class 379 Electrostar sits at London Liverpool Street with a service for Stansted Airport between Nos 745103 and 745107.

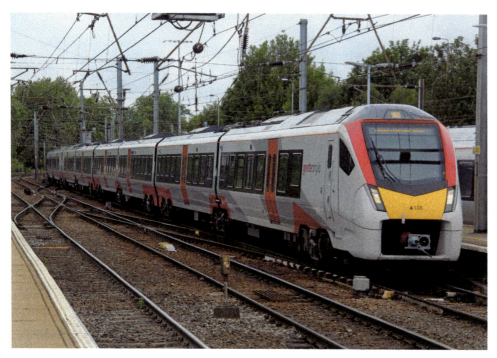

745108 arrives into Ipswich with a service for London Liverpool Street. It isn't uncommon to see one of the Stansted Airport Class 745/1s on these services, although with a lack of First Class and a bistro they are kept to a minimum.

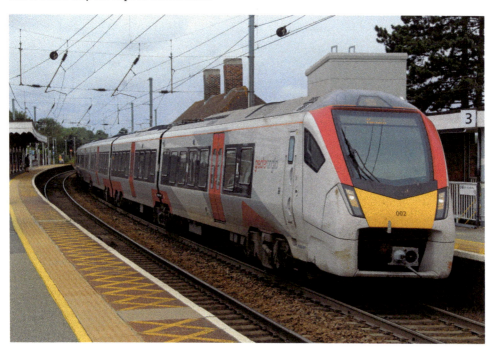

A filthy and work-worn No. 745002 is seen arriving into Manningtree with a service for Norwich.

Two new stations on the Greater Anglia network had opened; Cambridge North was built in May 2017 and Meridian Water in June 2019. The EMUs that were serving these new stations and the rest of the Greater Anglia network were still soldering on as the Aventras were still yet to enter service, which still gave them a longer life on the Greater Anglia network despite being on borrowed time.

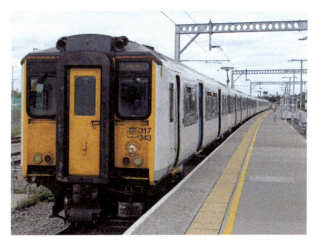

No. 317343 sits at Cambridge North with a service for London Liverpool Street. Opened in 2017, Cambridge North became part of the Greater Anglia network. The station was built to serve the nearby Cambridge Science Park and other nearby business parks. Cambridge North has proven a success and Greater Anglia operate regular services to and from Norwich, Cambridge, London Liverpool Street and Stansted Airport from this station.

No. 379022 sits at Meridian Water with a service for Stratford. This was another new station to open on the Greater Anglia network, opening in May 2019.

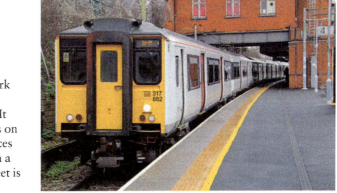

In 2018, due to electrification work on the Southend line there was a shortage of available Class 321s. It was possible to see the Class 317s on the GEML as they operated services to Braintree. Seen at Witham with a service for London Liverpool Street is No. 317882.

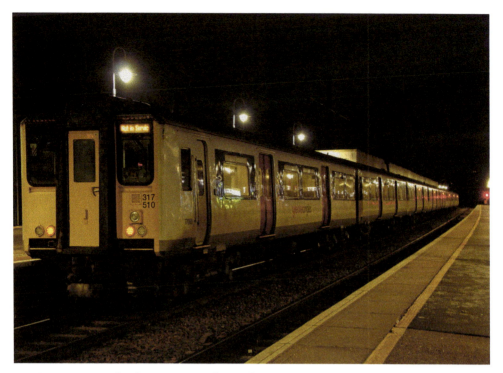

No. 317510 sits at Ely after arriving with a peak time train from London Liverpool Street. This train will now run ECS back to Cambridge yard.

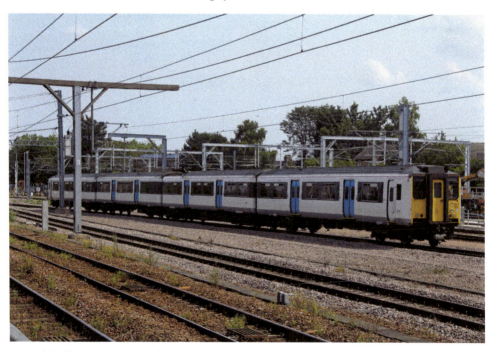

One of the former Great Northern Class 317, No. 317337 arrives into Cambridge with a service to London Liverpool Street.

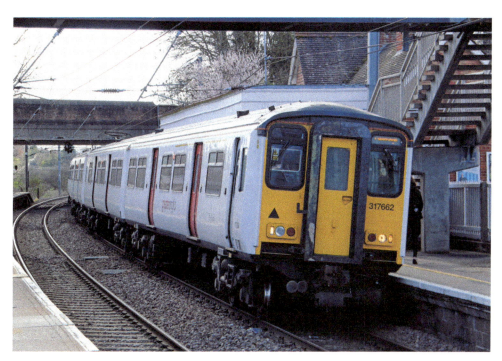

Nearing journey's end, No. 317662 sits at Whittlesford Parkway with a service for Cambridge North.

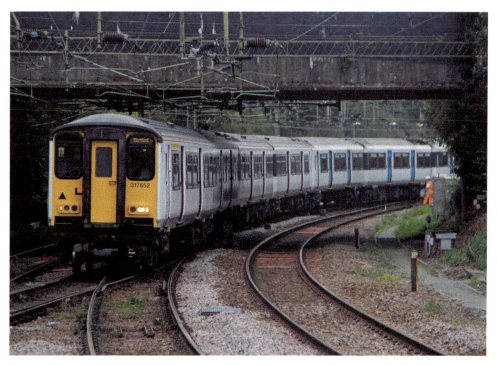

In preparation to form a service for Stratford, No. 317652 shunts out Bishop Stortford carriage sidings.

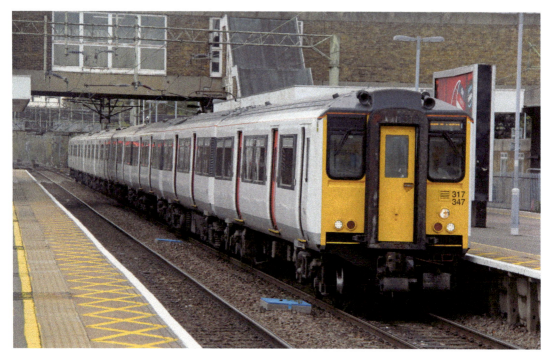

Above and below: No. 317347 passes through Broxbourne with an ECS movement to Hertford East. These units will stay there till later in the day before being used again during the evening peak. No. 317510 operates a service for Stratford. Services can be looped into platform 1 to allow faster trains to overtake on platform 2 before rejoining the WAML again.

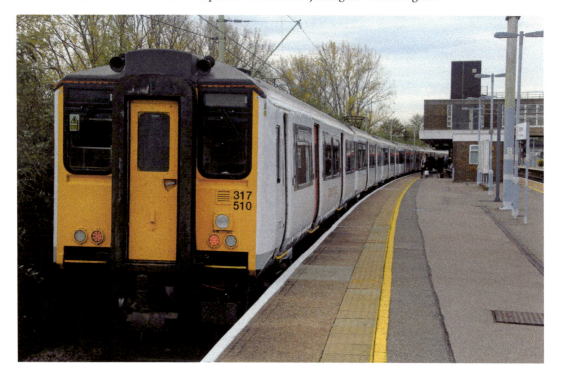

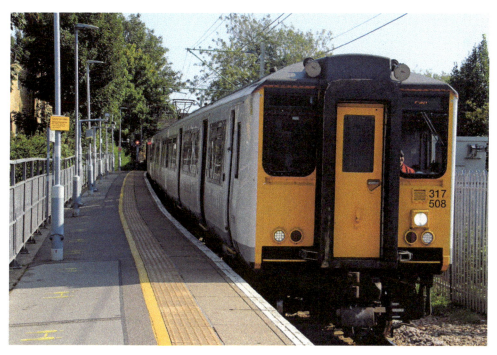

No. 317508 arrives into Ware with a service for Hertford East.

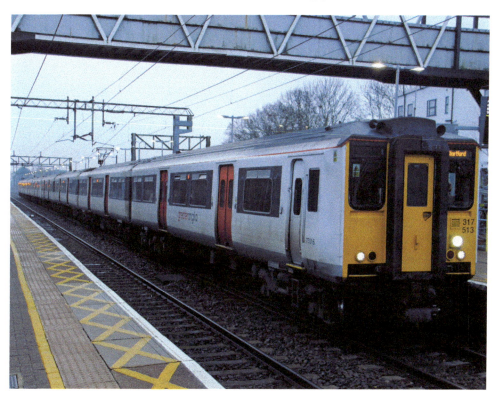

No. 317513 sits at Cheshunt with a service for Bishop's Stortford.

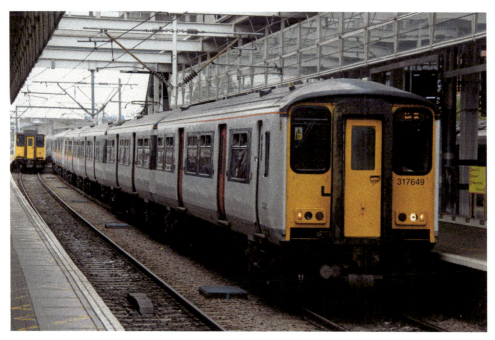

As No. 317348 departs Tottenham Hale with a service for Hertford East, No. 317649 arrives with a London Liverpool Street service. This station is used for passengers wishing to alight for services for Stratford and Meridian Water.

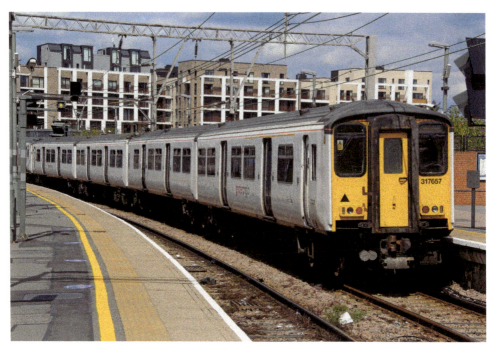

A regular service operates from Stratford to Meridian Water and Bishop's Stortford with the services alternating. No. 317657 sits at Stratford with a service for Bishop's Stortford. These services are fairly regular as it takes an hour for these trains to reach their destination.

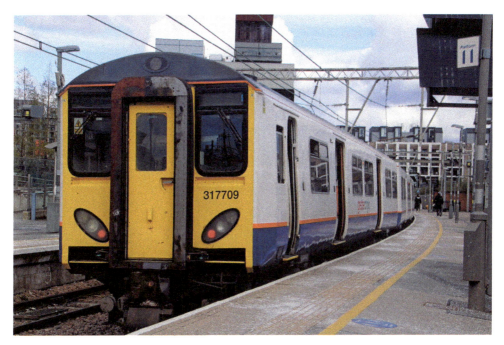

In 2021, the stored Class 317/7s had a short reprieve as they were put back into service on the WAML. No. 317709 is seen at Stratford with a service for Bishop's Stortford. Shortly after this image was taken the 317/7s were put back into storage again, with some of them heading for scrap in 2022.

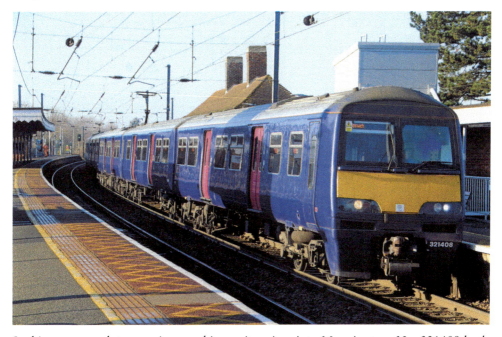

Soaking up some late morning sunshine as it arrives into Manningtree, No. 321408 leads an Ipswich service. This was one of ten that were transferred to Greater Anglia from Great Northern in 2016, much to the delight of passengers in the East.

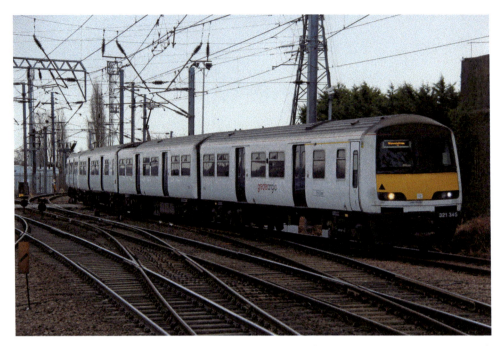

Class 321s could be seen working an hourly shuttle service between Manningtree and Harwich Town. No. 321345 arrives into Manningtree. It will sit in Manningtree for just under fifteen minute allowing both services from Norwich and London Liverpool Street to make a connection with this train.

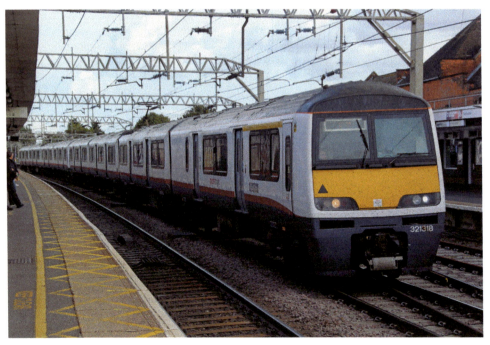

No. 321318 arrives into Colchester with No. 321312 on a service for London Liverpool Street. This service originated from Norwich and was covering an unavailable Class 90 loco-hauled set.

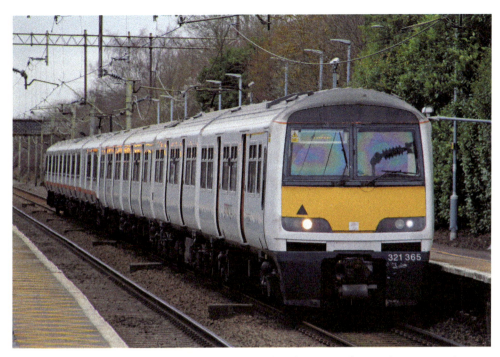

No. 321365 is seen passing through Hatfield Peverel with a service for London Liverpool Street.

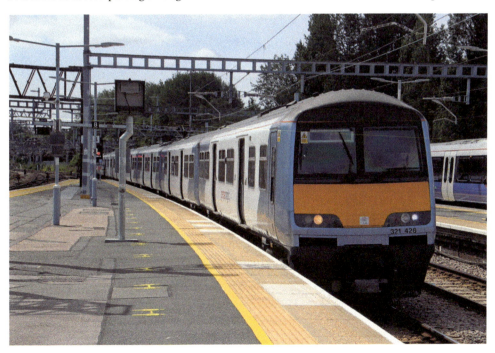

The Southend line was dominated by Class 321s for several years. A service departed both London Liverpool Street and Southend Victoria every twenty minutes, and to cope with the passenger demand the service usually operated as a pair. No. 321428 arrives with No. 321354 with a service for the coast.

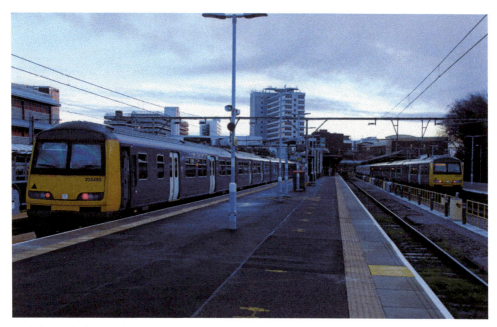

To help with the pending removal of Class 321s from service eight units, consisting of three Class 321/9s and five Class 322/4s, were transferred over to Greater Anglia after they had been ousted from their previous jobs up north by new Class 331s. Under the setting sun of Southend, both Nos 322483 and 322481 await departure for London again.

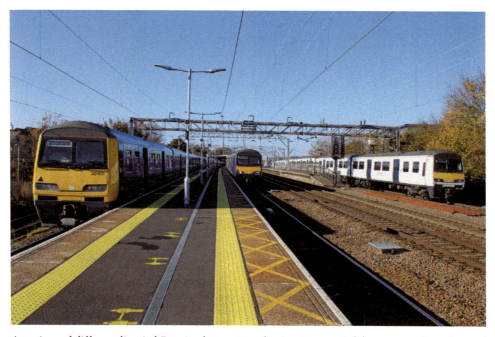

A variety of different liveried Dusties for various destinations at Colchester. Northern-liveried No. 321901 awaits departure with a service for Walton-on-the-Naze as First Capital Connect-liveried No. 321419 works an ECS movement into the station from the nearby yard and Greater Anglia-liveried No. 321346 departs with a service for Colchester Town.

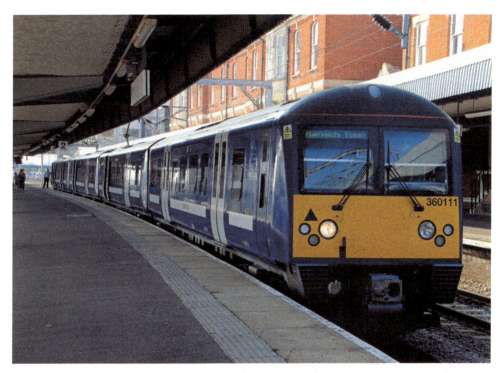

No. 360111 prepares for departure at Harwich International with a service for Harwich Town.

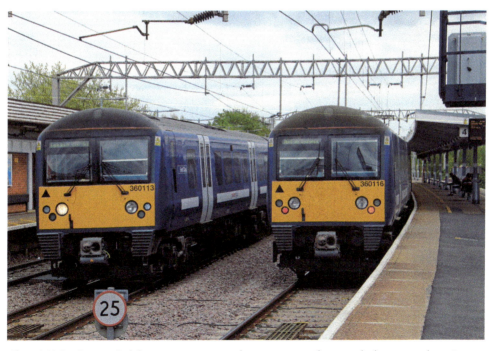

Class 360 Desiros at Colchester were extremely common as they regularly operated services to London Liverpool Street and Colchester Town. While arriving, No. 360113 passes No. 360116 working these aforementioned services.

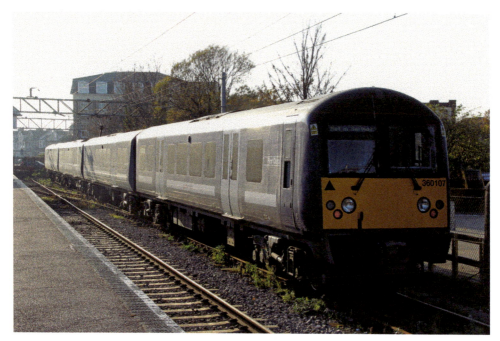

Alongside Ilford depot, where all of Greater Anglia's EMU are allocated, there is also a servicing depot located at Clacton-on-Sea and therefore it is regularly used to stable units that aren't in service, with two of the sidings visible from platform 1. No. 360107 sits in one of these sidings awaiting its next duty.

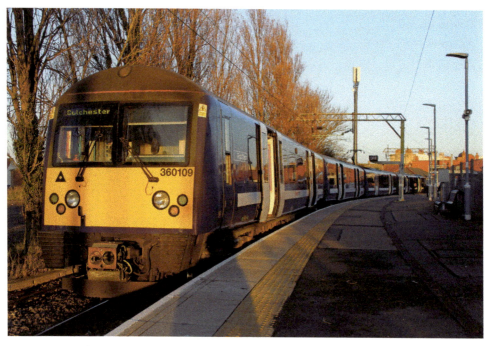

Having arrived at Walton-on-the-Naze, No. 360109 will sit here for ten minutes before performing a service back to Colchester.

Greater Anglia: The First Ten Years

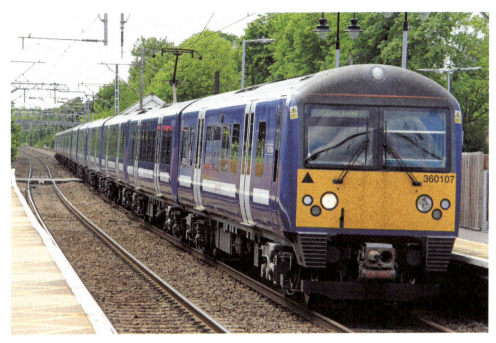

Nos 360107, 360110 and 360116 arrive into Ingatestone station. This train is running in a twelve-carriage formation in preparation for the evening peak; it will most likely stay fairly empty on its current diagram before filling up with commuters on its return diagram back to London Liverpool Street.

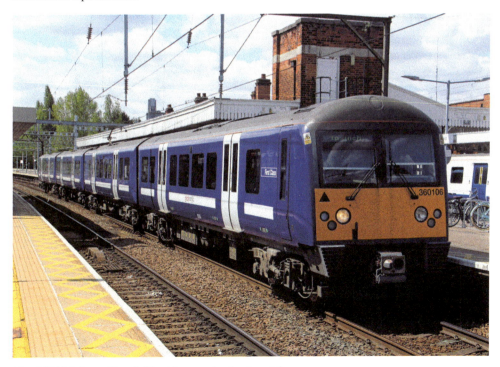

No. 360106 sits at Shenfield with a service for Ipswich.

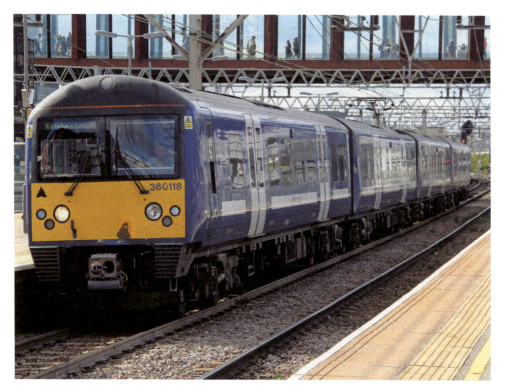

No. 360118 arrives into Stratford with a service for Colchester Town.

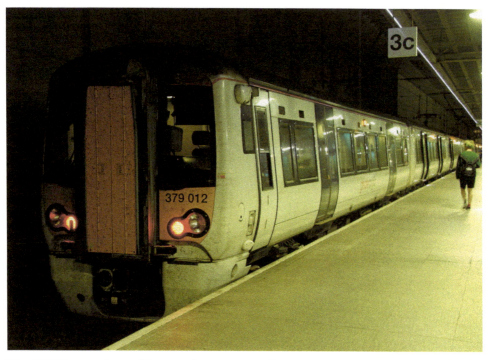

No. 379012 sits at Stansted Airport after arriving with a service from the capital.

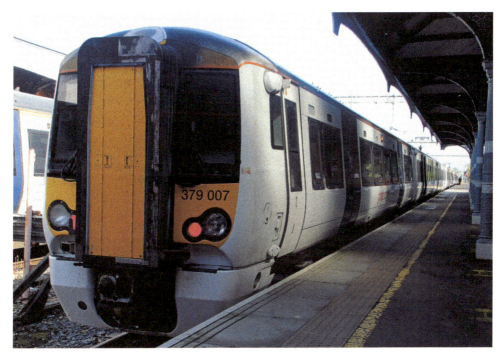

Units can be found stabled at Hertford East, where they will spend most of the day before heading back into London Liverpool Street in time for the evening peak. No. 379007 rests up before its next diagram.

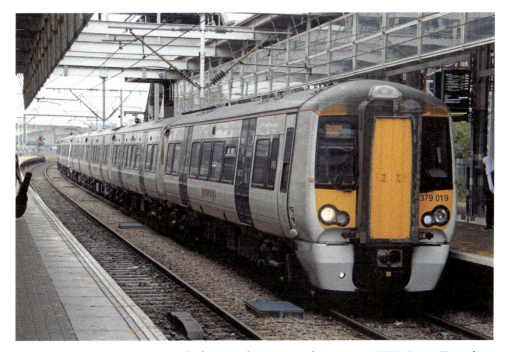

Arriving into its penultimate stop before London Liverpool Street, No. 379019 is at Tottenham Hale with a service from Stansted Airport.

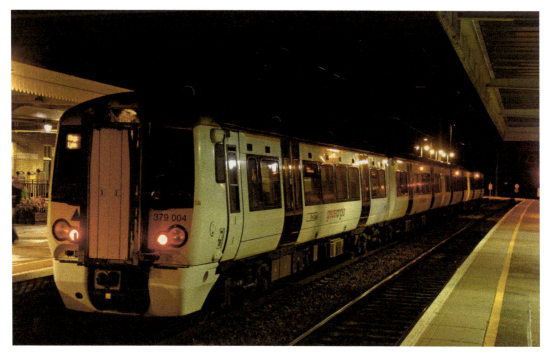

Above and below: In the evening peak, Greater Anglia operate a service to King's Lynn, a station which is served by Great Northern all day. No. 379004 is seen at Ely awaiting departure for King's Lynn while No. 379021 sits at King's Lynn waiting to head to Cambridge ECS.

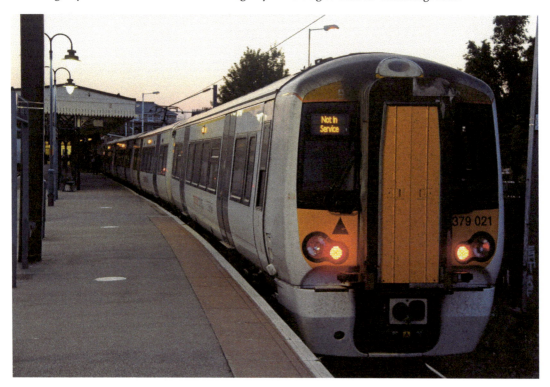

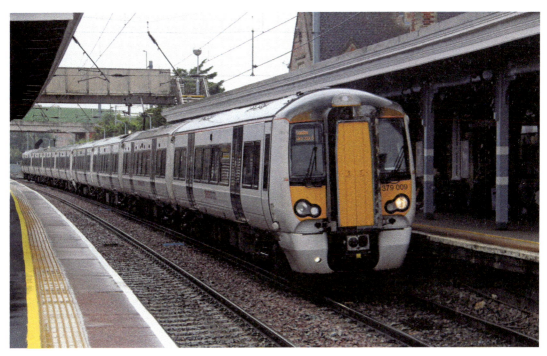

Above and below: In August 2018, issues with the OHLE saw Nos 379008 and 379009 utilised on the GEML to check the overhead wires for problems. These units were used specially for their onboard pantograph cameras.

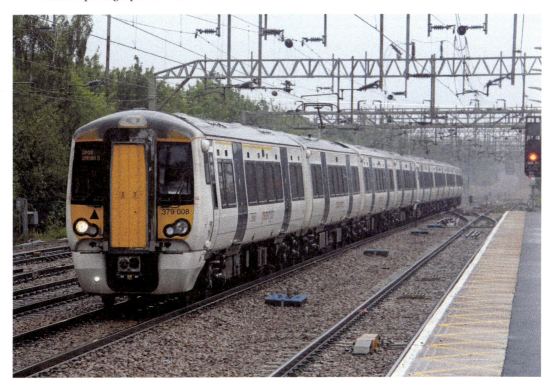

27 November 2020 saw the first Class 720 Aventra (No. 720515) start working services between London Liverpool Street and Southend Victoria. Since this date more have been built and released into traffic, and they have become a common sight as they work on all lines out of London Liverpool Street.

The show must go on even in snowy conditions. No. 720537 sits at Ipswich with a test run to London Liverpool Street.

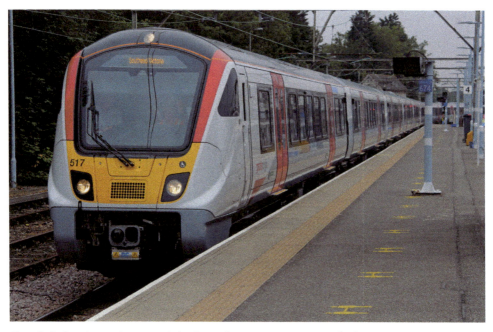

Shortly before becoming one of the first Class 720 Aventras pushed into traffic, No. 720517 arrives at Southend Victoria on a driver training run from Shenfield.

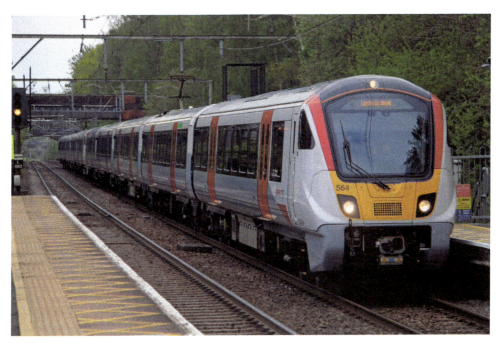

The testing of the Aventras was carried out regularly and they could be seen every weekday. The unit usually stabled at Harwich before heading to Colchester before reversing and heading to Ipswich, where it would reverse again and head to London Liverpool Street. In May 2021, No. 720564 is seen heading towards London Liverpool Street on this diagram.

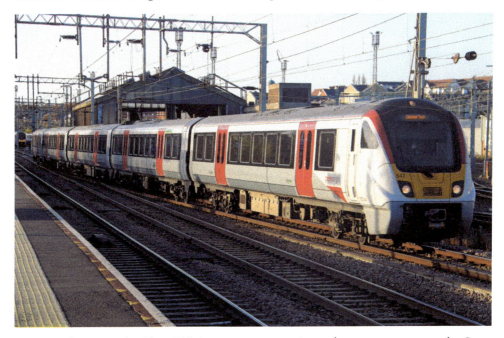

By November 2021 the Class 720 Aventras were starting to become common on the Great Eastern Main Line, especially on services towards Clacton-on-Sea, with No. 720547 filling one of the diagrams.

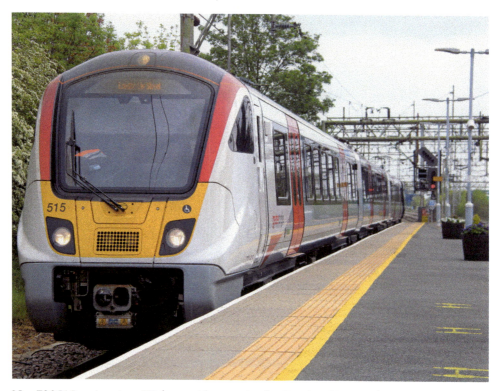

No. 720515 arrives into Witham with a service for London Liverpool Street. The Aventras started operating services on these lines in December 2020, replacing the Class 321s.

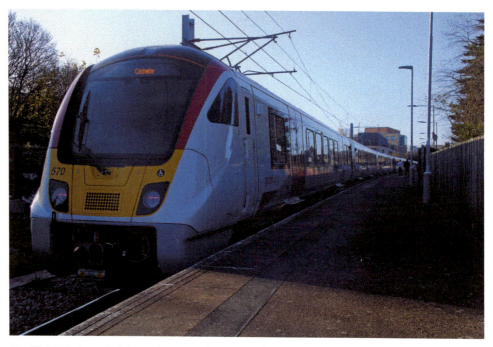

No. 720570 sits at Colchester Town with a service for London Liverpool Street.

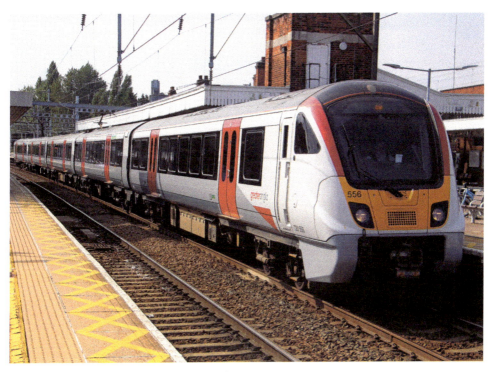

No. 720556 sits at Shenfield with a service for Braintree.

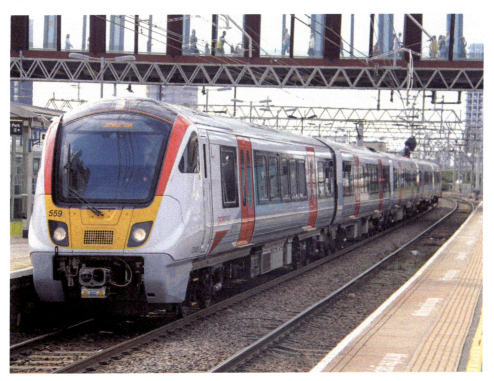

No. 720559 arrives into Stratford with a service for Colchester Town.

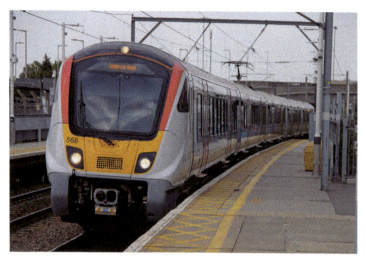

August 2021 saw the Aventras reach the West Anglia Main Line. No. 720568 arrives into Tottenham Hale with a service from Cambridge. One month later newly introduced No. 720566 sits at London Liverpool Street with a service from Cambridge North.

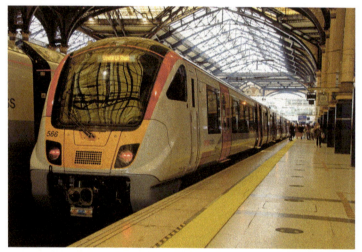

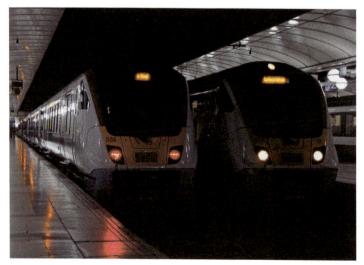

Once the first few Class 720s were accepted into service, it wasn't long before more followed. Nos 720556 and 720561 sit at London Liverpool Street with services to and from Southend Victoria.

Pastures New for Old Trains

When it was announced that Greater Anglia were planning to replace all of their current trains, it meant finding new homes for them. With many operators having already bought new trains, they wouldn't have been interested in the older trains that Greater Anglia had on offer and with a new DDA compliance law for trains coming into place in January 2020, a lot of trains would need upgrading otherwise they would need to be withdrawn from service. However, Greater Anglia did manage to rehome much of their older fleet.

Class 90/Mk3 Loco-hauled Sets

The 90 sets that operated between Norwich and London Liverpool Street weren't DDA compliant due to the slam doors and no passenger information displays in the seating areas, whereas other operators had the slam doors on their Mk3 carriages replaced with automatic sliding doors to allow them to keep operating. Greater Anglia were going to have them replaced with Class 745s so they were going to be an unnecessary expense.

The Class 745s were delayed entering service due to initial issues with the Class 755s. The minor setback of the new trains forced Greater Anglia to get permission from the Department for Transport (DfT) to continue running these loco-hauled sets until the Class 745s were able to enter service.

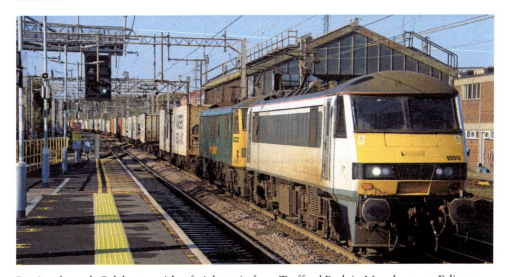

Passing through Colchester with a freight train from Trafford Park in Manchester to Felixstowe, one of the thirteen Class 90 recently transferred to Freightliner, No. 90010 heads the train with No. 90016.

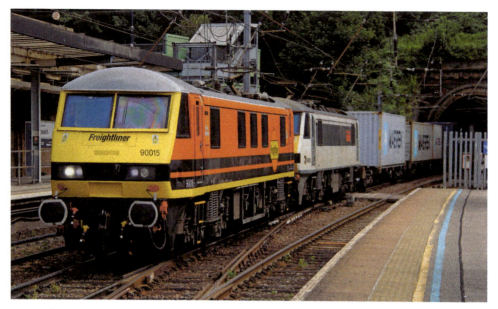

Since Class 90s were already common to Ipswich on both passenger and freight services they didn't need testing before being sent back to their home turf. Freightliner was also quick to change the Greater Anglia white to a much more brighter and vibrant orange and black, which No. 90015 shows off as it arrives into Ipswich with another former Greater Anglia Class 90, No. 90006, which had yet to be painted.

Freightliner announced they were to take the majority of the Class 90s, with thirteen locomotives moving there, while two others were to find a new life with Locomotive Services Limited (LSL) working railtours across the UK. This would also see them being repainted into the InterCity livery. In January 2020, the first Class 90, No. 90014, left Norwich for Crewe as it needed an exam and by May 2020 the final five had departed.

A majority of the Mk3 carriages and the DVTs were scrapped, with one set being transferred to Chiltern Railways and a small amount being bought by preserved railways.

Due to the Coronavirus pandemic in 2020, these loco-hauled sets sadly never got the send off they deserved after spending sixteen years ferrying passengers between Norwich and London.

Class 153/156 Sprinters

The Class 153s were quickly being replaced by the FLIRTs, and once enough of them were in service the 153s were quickly ousted from their duties.

Despite their small size and not being DDA compliant, Transport for Wales snapped all five of them up. In December 2019, Nos 153306 and 153335 left Norwich, with Nos 153309, 153314 and 153322 departing the following day. They can now be seen working in and around South Wales and further afield.

All nine of Greater Anglia Class 156 Sprinters were transferred to East Midlands Railway. These units have been reclassified as Class 156/9s due to the Passenger Information System equipment that had been installed on them not being compatible with East Midlands Railway's existing fleet of 156s. They have also received a new livery, with the majority of the bodywork still being white but now sporting purple ends.

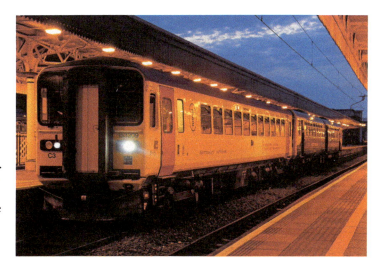

One of the five Greater Anglia Class 153 Sprinters snapped up by Transport for Wales was No. 153309, pausing at Cardiff Central with a service for Rhymney. No. 153309 would later go on to receive the Transport for Wales grey livery and be renumbered No. 153909 due to it not being DDA compliant.

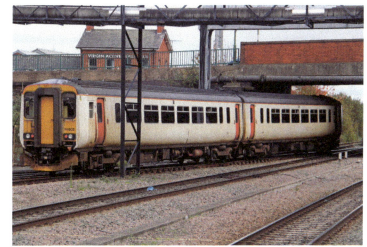

The durable Class 156 Sprinters had spent a lot of their careers in and around East Anglia, with many being based at Norwich Crown Point when built before transferring away. No. 156419 sits at Peterborough wearing the new colours of East Midlands Railway and displaying its current number of No. 156919, powering a service for Lincoln Central. East Midlands Railway didn't take long to apply their colours and branding to their newly acquired Sprinters; however, No. 156902 (156402) regularly avoided the change, departing Nottingham with a service for Skegness in full Greater Anglia livery.

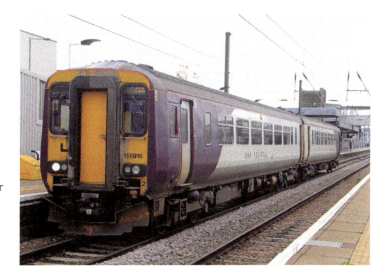

Class 170 Turbostars

As they were still fairly modern, it wasn't long before these units were also snapped up by Transport for Wales, with the first one (No. 170207) departing East Anglia in September 2019. Ten more followed as the weeks passed and more FLIRTs came into traffic but the last one, No. 170271, did not reach Wales until February 2020 due to issues with the new FLIRTs. They have all kept the same livery due to it being virtually identical to the Transport for Wales livery.

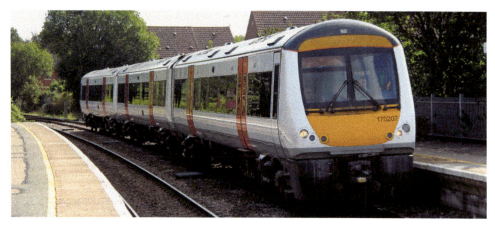

The first DMU to leave Greater Anglia was No. 170207, leaving for Wales on 1 September 2019. Cleaned up and with all Greater Anglia branding removed, it is seen passing through Thetford on an ECS movement from Norwich Crown Point depot to Cardiff Canton depot.

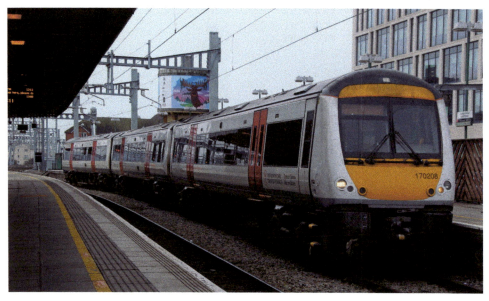

Transport for Wales also snapped up all twelve of the Class 170 Turbostars including No. 170208, replacing the elderly Pacers on the Ebbw Vale Town services, as well as increasing capacity on services from Cheltenham Spa/Gloucester towards Cardiff and Maesteg. The only noticeable change was the Transport for Wales logo replacing the Greater Anglia logo. They are to leave Wales by the end of 2022 for East Midlands Railway.

Class 317s

Built in the early 1980s, the Class 317s were Greater Anglia's oldest EMUs and after a varied career working on the East, West and Midland main lines this unit became synonymous with the West Anglia Main Line. After receiving the twelve from Great Northern in 2017, Greater Anglia became the sole operator of these EMUs and began to strengthen services during the peak periods, to the delight of the commuters.

When it was announced that all fifty-seven of Greater Anglia's Class 317s were going to be replaced by the Class 720 Aventra, the writing was on the wall as all other TOCs had already bought new EMUs or had newer EMUs transferred over. None of these units were DDA compliant, but due to a delay in the Aventras coming into service Greater Anglia were forced to send some 317s away to Kilmarnock for DDA upgrades. Even with these modifications installed they still remained unwanted and they started going for scrap in 2020 with the entire /6 subclass being removed from service first.

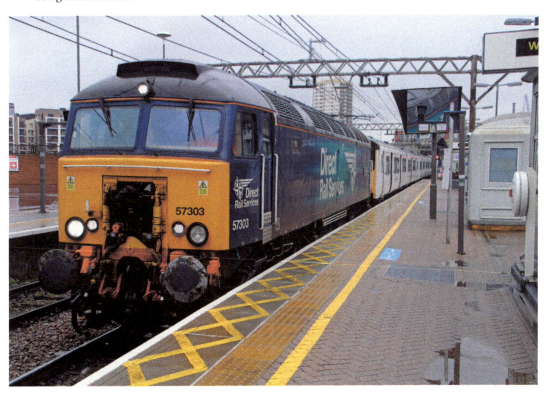

It sadly wasn't good news for all of Greater Anglia's EMU stock, especially the older Class 317s, which had been around since the 1980s. With them not being DDA compliant and also suffering other issues such as corrosion damage, it was inevitable which direction the Class 317s were going to take. DRS Class 57 No. 57303, on hire to Rail Operations Group (ROG), is seen passing through Stratford with Nos 317666 and 317503 heading to Eastleigh, where both 317s will be scrapped.

Class 321s

Greater Anglia's second oldest EMU, the majority of these units had spent their entire lives working out of London Liverpool Street, with some working on both the East and West Coast Main Line, before all of them moved to the Great Eastern Main Line when Greater Anglia took ownership of ten Class 321s from Great Northern in 2016, followed by three Class 321/9s and five Class 322s from Northern in 2020.

A lot of these units, much like the Class 317s, have come to the end of their working lives with many going for scrap. However the 'Renatus' 321s still soldier on. All of the non-DDA compliant classmates have been stood down as more Class 720s are released into service. This hasn't become the final stop for some of the 321s as they start a new chapter being used for experimenting with hydrogen power and parcel traffic.

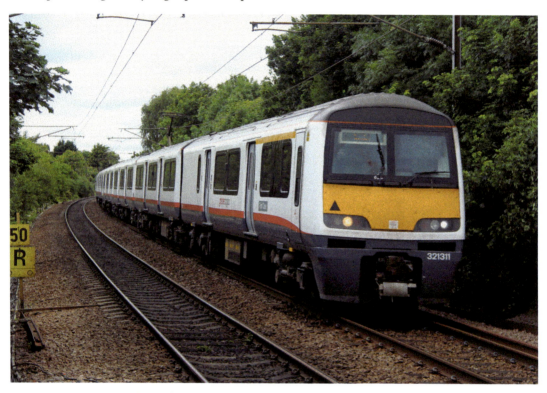

No. 321311 passes through Needham Market with a service for London Liverpool Street. At the time of this image in the summer of 2019 this would have been covering for a loco-hauled Class 90 set, which was used for the Norwich in 90 diagrams. By the start of 2022, this would be one of thirty original Greater Anglia 321s left in service.

Class 360 Desiros

The twenty-one (Nos 360101–360121) four-carriage Class 360 Desiros entered service for First Great Eastern on the Great Eastern Main Line back in 2004. All twenty-one of these units passed to National Express and later Greater Anglia, who continued to operate these trains between London Liverpool Street and Clacton-on-Sea, Colchester, Ipswich and Harwich.

They weren't immune from the invasion of Class 720s that were coming to replace them and it wasn't long before they found work elsewhere. In 2019, when Abellio won the East Midlands franchise they were going to introduce a new service between London St Pancras and Corby. Originally named EMR Electrics, it was later renamed EMR Connect. The twice-hourly service was to use the redundant Greater Anglia Class 360 Desiros, which also received a pantograph modification and a maximum speed upgrade to 110 mph to allow them to run a faster service on the Midland Mainline. While many of them have received their new operators' livery, a large number of them still carry FGE blue from when they were first built.

GBRF Class 47s Nos 47739 and 47727 slowly pass through Stratford with Class 360 Desiro No. 360120 sandwiched in the middle. This was heading back to Ilford depot after receiving modifications to its pantograph in Northampton in preparation for its new future on the Midland Main Line.

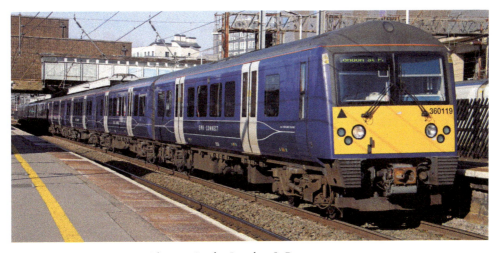

No. 360119 sits at Luton with a service for London St Pancras.

Class 379 Electrostars

Thirty Class 379 Electrostars (Nos 379001–379030) were built between 2010 and 2011 to improve West Anglia Main Line services and replace the much older Class 317s on the airport services between London Liverpool Street and Stansted Airport, as well as other services on the WAML to places such as Cambridge.

The Class 379s, like their predecessors, worked in multiple and had gangway doors allowing easy access between the units. However, they also had more luggage areas, air-conditioning and plug sockets. After taking over the Stansted Express diagrams from the Class 317/7s they were put into storage after they became surplus to requirements.

History on the WAML has repeated itself in recent times as the Class 379s have now found themselves being replaced, as they were ousted from Stansted Airport diagrams in 2020 by the Class 745/1 FLIRTs. Since then they have started taking over more and more 317 diagrams. These are also due to be replaced by Class 720 Aventras, although their future moving forward is unknown despite being a relatively new unit.

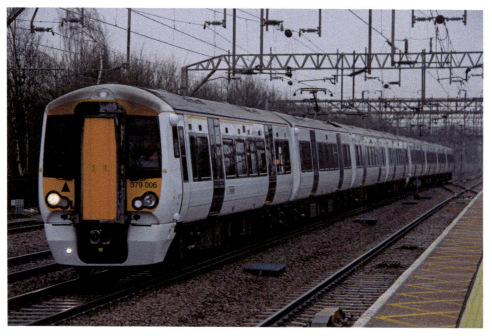

The last of the original Greater Anglia trains with an unknown future ahead of them. After spending some time parked up in a holding siding at Harwich, Nos 379006 and 379023 pass Colchester as they head back towards Ilford depot.